Then & Now

CEDAR RAPIDS

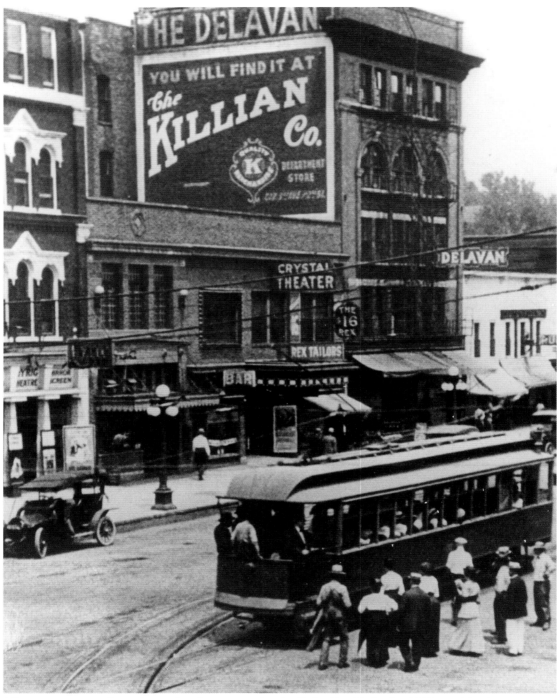

The street car was the main mode of transportation in Cedar Rapids in the 1920s, as this view across First Avenue from Third Street SE shows. There are cars on the street also and plenty of curbside parking. The Crystal Theater (which later became the Rialto Theater), the Delavan Hotel, and a big sign advertising Killian's Department Store are in the background. (Photo courtesy of the Linn County Historical Society, which will be called The History Center throughout this publication.)

THEN & NOW

CEDAR RAPIDS

George T. Henry and Mark W. Hunter

ARCADIA

Published by Arcadia Publishing,
an imprint of Tempus Publishing, Inc.
Charleston SC, Chicago, Portsmouth NH,
San Francisco

Printed in Great Britain.

Library of Congress Catalog Card Number: Applied For.

For all general information contact Arcadia Publishing at:
Telephone 843-853-2070
Fax 843-853-0044
E-Mail sales@arcadiapublishing.com
For customer service and orders:
Toll-Free 1-888-313-2665

Visit us on the internet at http://www.arcadiapublishing.com

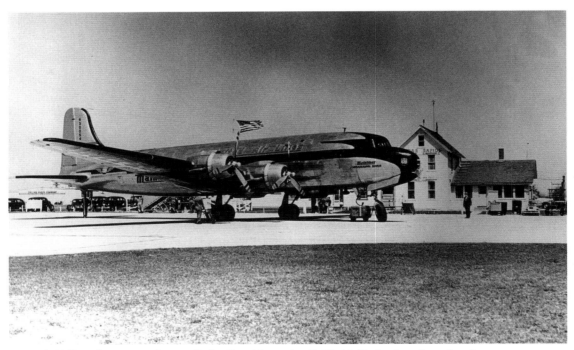

United Airlines began service to Cedar Rapids on April 27, 1947. At that time the airport passenger terminal consisted of a farmhouse, and the first planes were called Mainliners. Many planes had names and this one was called the *Mississippi River*, a Douglas four-engine DC-4. (Photo courtesy of The History Center.)

CONTENTS

ACKNOWLEDGMENTS

In most cases, this book pairs historical scenes from the Cedar Rapids History Center files with today's view from the same location. It is the second in what is becoming a series of pictorial history books about Cedar Rapids, sponsored by the Linn County Historical Society, also known as The History Center. Historian Mark Hunter and I are already planning another "Then and Now" book for issue in 2005, as there are many more historical photographs of interest that could not be included in this book.

Without the cooperation of The History Center and their employees and volunteers, publishing this book would not have been possible. The people of Cedar Rapids also gave me their whole-hearted support, advice, time, and temporary access to their photo collections. Special thanks must go to Carolyn Schmidt, with whom I worked for many years at Coe College. She provided typing and editing help.

George T. Henry
July 2003

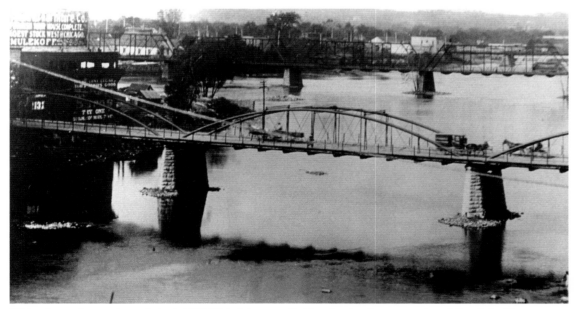

This photo shows the original 1871 Third Avenue Bridge in the foreground and Smulekoffs Furniture Store (known as the Island Store) on Mays Island in the background. The year is about 1900, so there is no Second Avenue Bridge. In the background is the old First Avenue Bridge. (Photo courtesy of The History Center.)

INTRODUCTION

"Then and Now" books are of a great deal of interest to those who remember or try to remember changes that have taken place in a community. The past gets hazy as the years pass, and a photo taken years ago can help us remember a business, a home, a bridge, or some other landmark from our history. This book will help place those memories as the camera goes back to the same scene and duplicates the view as it appears today. Some of the subjects are still there and have changed very little. Others have changed a great deal or are gone completely.

Cedar Rapids is unique in many ways. One of the most unusual features is the location of the official city offices on an island in the middle of the Cedar River. In 1900, Cedar Rapids was also called the Parlor City or the Queen City. Today it is known as the City of Five Seasons—the traditional four seasons plus a fifth to enjoy the other four.

A century ago, Cedar Rapids was known for its massive grain processing plants, and today those plants are even more massive and successful—producing everything from cornstarch to corn flakes. Cedar Rapids is known not only for its agricultural products, but also for communications industries, ranging from radio to avionics, and from manufacturing to telecommunications.

Cedar Rapids' location is a prime area for human habitation, with access to river resources and fertile farmland. The area has a history of more than 10,000 years of occupation by Native Americans. Although we have archeological evidence of Native American ways of life, we have no photographs. Even though we have documentation of Euro-American settlers in the late 1830s, we have no photographs of Cedar Rapids at that early stage of development.

In 1842, a plat was filed for Cedar Rapids and the first frame house was built by John Vardy. The population of Cedar Rapids was eight. By 1847, the first school building, post office, and hotel were built. Cedar Rapids was incorporated by the legislature on January 15, 1849.

A chronological tour through the city illustrates how active and progressive Cedar Rapids has been since its early days. Cedar Rapids grew quickly, prospered, and early on, focused on education. The Cedar Rapids Collegiate Institute was opened in 1851. Its name changed to Coe College in 1875, and today the college is a strong four-year liberal arts institution of 1,300 students.

In 1856, Cedar Rapids was reincorporated and the first bridge was erected across the Cedar River. Unfortunately, the bridge washed away during the spring flood the following year. In 1858, on a lot at Third Avenue and Third Street SE (later the site of the Montrose Hotel and now the location of the Town Centre building), the first taxes were levied. The assessment was $1.10 on a listed evaluation of $550. Also, by 1858 the city's population had grown to 1,400. The first train arrived in Cedar Rapids on June 15, 1859 amid a huge celebration.

Noteworthy buildings like the Masonic Temple and St. Luke's Hospital arrived on the scene in 1884, a year after the Cedar Rapids *Gazette* was founded and published its first evening paper on January 10. Also in 1884, street designations were changed from names to numbers, and "West" was added to all streets on the west side of the river.

The beautiful Union Station was constructed in 1897 on Fourth Street SE, between Third and Fifth Avenues. Facing Greene Square Park, it became a fashionable and impressive entryway into Cedar Rapids, especially for the 99 passenger trains that came through town each day. Mercy Hospital was originally opened in a residence in 1900, but a larger building was constructed in 1903. The Quaker Oats Company plant was destroyed by fire in 1905 and then quickly rebuilt.

The commission form of government was established in 1908, and the City Council purchased May's Island for park and public building purposes. In 1919, the Douglas Starch Works explosion made national news. The blast was felt for miles around and completely leveled the plant. Also in 1919, voters approved moving the Linn County Courthouse from Marion to Cedar Rapids, and in 1924–1925 the courthouse was built on May's Island.

Construction of Veterans' Memorial Coliseum on May's Island was completed in the late 1920s. Also at this time, the Paramount Theater was built and Mount Mercy College was established. In 1931, the combined Federal Building and Post Office was constructed at the corner of First Avenue and First Street SE. The new Municipal Airport was established in 1944. In 1949, Veterans' Memorial Stadium was completed, and Cedar Rapids moved its semi-professional baseball team from Belden Hill Park to the new location. In the same year, Kingston Stadium was also built for the city's high school football teams. In the 1950s and 1960s, new high schools were built, including Washington, Jefferson, Regis, LaSalle, and Kennedy. Throughout the 1960s and 1970s, Cedar Rapids was awash in construction due to an enormous influx of urban renewal funding.

This book deals visually with the changes that have been made in Cedar Rapids over the past 120 years. Many readers will remember at least some of them. We both rejoice and lament about what change has meant. However this book will show the past as it coincides with the present, leaving interpretations to the reader.

Chapter 1

DOWNTOWN
CEDAR RAPIDS

The downtown area of Cedar Rapids has always been busy. Merchants built, rented, and moved from place to place. However, downtown in the early days basically consisted of the area between the Fourth Street tracks and the Cedar River, and merchants were concentrated between First Avenue and Third Avenue SE. There was some movement out of that confined area but not too much for the retail trade in the first 100 years.

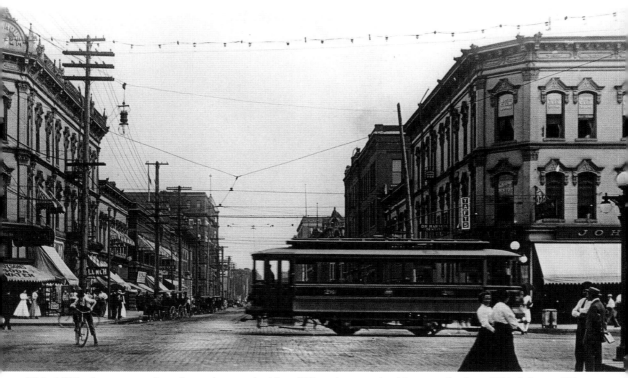

This 1905 photo was taken from the north side of First Avenue, looking south along Third Street SE. On the near right is Taft's corner, which became the first Killian's Department Store between 1911 and 1913. Killian's then moved to its permanent location at Third Avenue and Second Street SE. Some of us still remember that Kresge's Dime Store was located on the old Taft's corner after Killian's moved out. The corner is now a US Bank parking lot. The building on the left corner was demolished in 1927 and replaced in 1928 by the Iowa Theater, which is now the home of Theatre Cedar Rapids. (Photo courtesy of The History Center.)

The downtown area of Cedar Rapids looks much different today when viewed down First Street SE towards Quaker Oats. The smaller buildings that were commercial storefront businesses moved to new locations. Others just closed their doors. Quaker Oats in the background, however, has basically remained unchanged. (Top photo courtesy of The History Center, bottom photo courtesy of George T. Henry.)

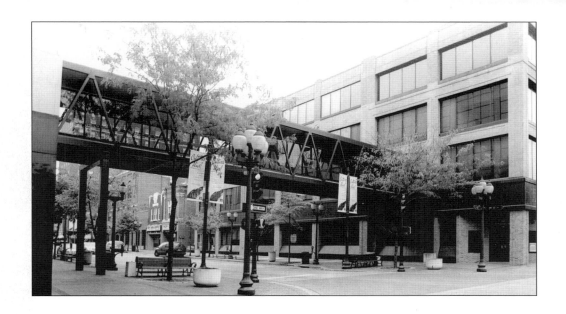

The old Mansfield block ran north from the corner of Second Street and Second Avenue SE. It was the first home of Armstrong's Department Store, which was established in 1890. The building was remodeled over 30 times during the 68 years Armstrong's was located there. A fourth floor was added in the 1930s, and the entire exterior was redecorated with new brick and windows.

In 1959 Armstrongs moved to Third Avenue and Third Street, and the Second Avenue building became known as the SGA (Samuel G. Armstrong) Building. From the early 1980s until 2001, the building was the home of SCI (Security Corporation of Iowa), a financial corporation. (Top photo courtesy of George T. Henry, bottom photo courtesy of The History Center.)

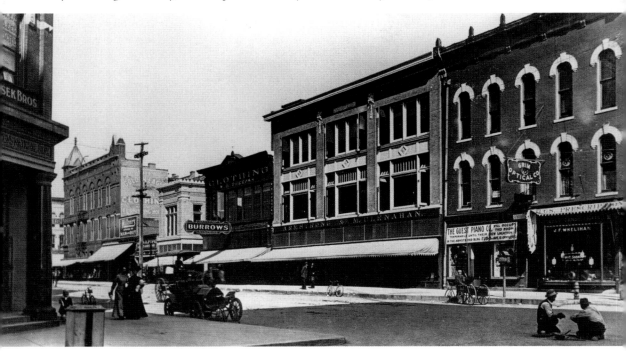

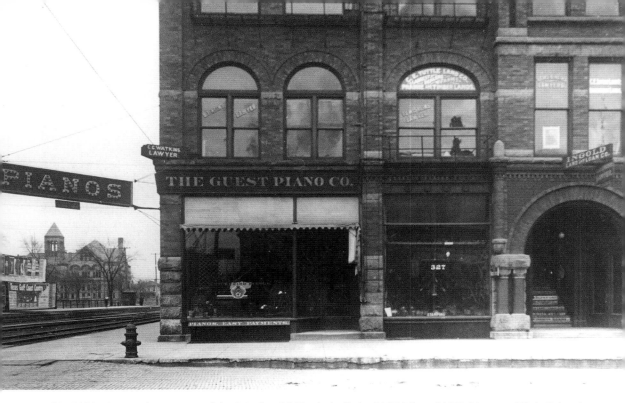

This 1900 picture shows part of the Muskwaki block, built in 1897. The old Washington High School, located across from Greene Square Park, is visible in the left background of this shot across multiple railroad tracks. The upper floors of the Muskwaki building were originally a mixture of offices and businesses until the 1930s when this area was converted into apartments.

The Dragon restaurant opened its doors on this corner in 1948 and has been a landmark restaurant at 329 Second Avenue SE since then. (It was sold recently and its future was unknown at press time.)

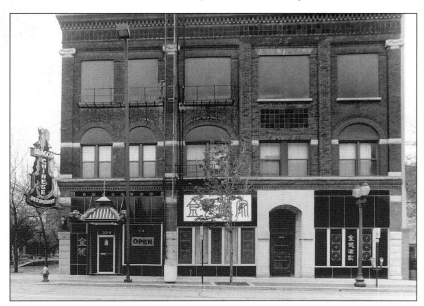

Although changes are visible in the upstairs entrance, the lower corner of the building still contains the same stone that the builder put in place when the building was erected. (Top photo courtesy of The History Center, bottom photo courtesy of George T. Henry.)

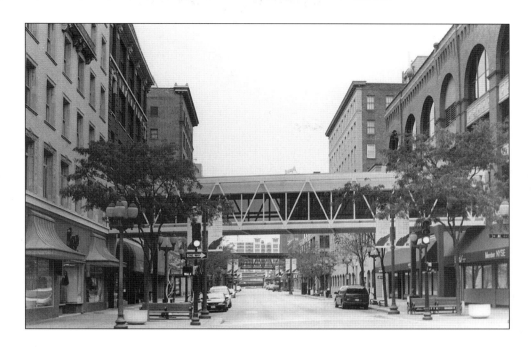

Looking north from Third Avenue on Second Street SE towards Second Avenue about 1910, one could still see more horses than cars on the streets. The small wooden buildings on the left were replaced by the Mullin building and the new Higley building, but the Security building still stands and is now a part of United Fire and Casualty Company. The sidewalk overpass was added in the mid–1980s. The Granby building is visible on the right. (Top photo courtesy of George T. Henry, bottom photo courtesy of The History Center.)

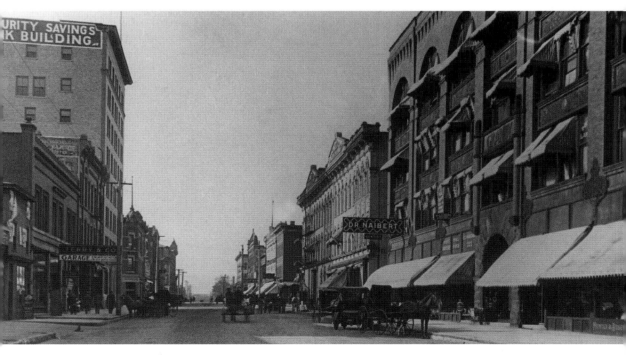

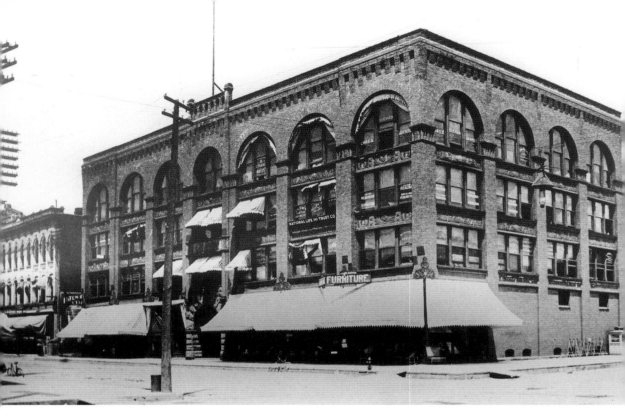

The Granby building on the northeast corner of Second Street and Third Avenue SE was built in 1891. It was constructed for the Higley family who owned many prime corners in downtown Cedar Rapids. The Higleys hailed from West Granby, Connecticut, and after coming to Cedar Rapids, this building was named after their old hometown.

The building has survived for well over 110 years but was almost demolished during an expansion of

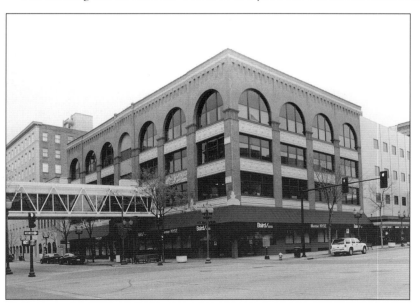

Armstrong's store in the early 1970s. Instead of being replaced, however, the building was painted white and the windows were covered. In 1991 it was restored to its original appearance. (Top photo courtesy of The History Center, bottom photo courtesy of George T. Henry.)

These wonderful old buildings once stood across First Avenue in this view from Second Street SE looking towards the river. From the right is the 1870 Union block with its distinctive mansard roof. The two-story structure to the left became the Baranchanus Steak House, a popular restaurant, in later years. Next is the Kilborn block and the magnificent five-story old Masonic Temple building that later became known as the ORCB (Order of Railway Conductors and Brakeman) building. Across First Street NE is the old YMCA building, dated 1888.

Today everything is gone, as the area was demolished in 1969. In 1974, the Cedar River Tower apartment building was constructed, and in the following year work began on the Brenton Bank building which is noted for it rust-like exterior. (Top photo courtesy of George T. Henry, bottom photo courtesy of The History Center.)

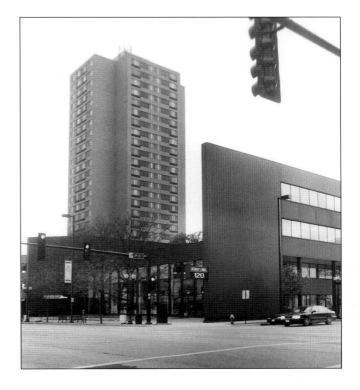

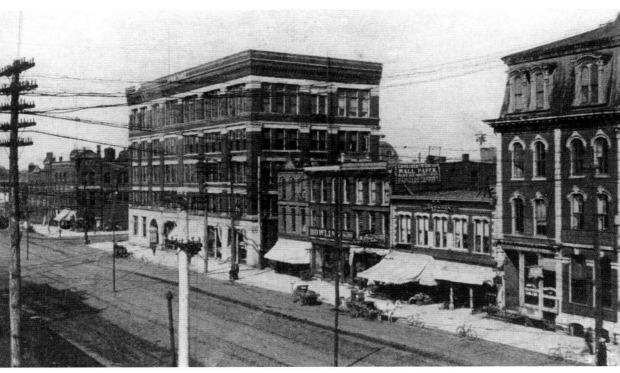

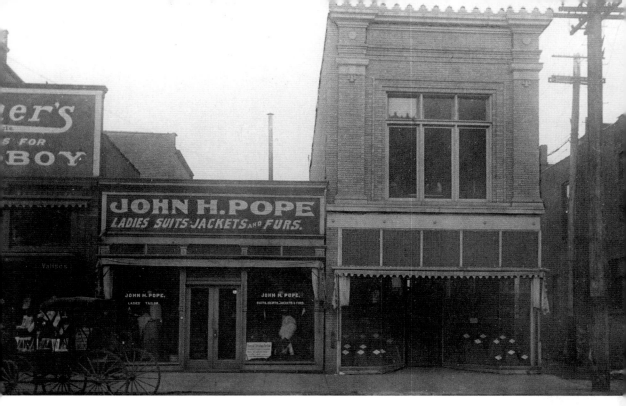

At 110 Second Street SE was the John H. Pope Clothing Store, which was replaced by a new structure in 1911. Charles Greenburg, a furrier, was then located there for many years. Next door on the right at 112 Second Street SE was for several decades the Star Jewelry Company. Armstrong's formerly used this building (112) for their bridal department, connecting to their old department store in the 1940s and 1950s.

After much remodeling in 2002, the New China restaurant opened on this site, with apartments above. (Top photo courtesy of The History Center, bottom photo courtesy of George T. Henry.)

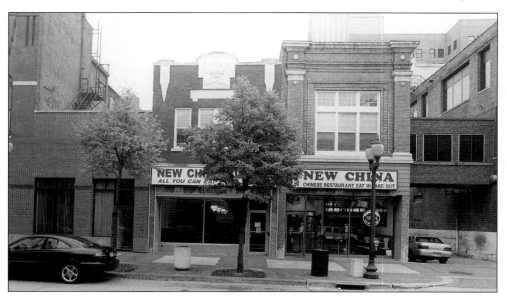

As was the case in most areas of downtown, small shops and businesses were the rule. In this 1968 photo, the Barber College was on the left, then Stalker Electric, which had replaced the Brems Bakery. The building to the right, with the big John Culver sign, was originally a wholesale fruit and vegetable warehouse and later an apartment hotel. By 1970, most of these buildings had been demolished as part of an enormous urban renewal effort. The 200 block of First Street SE was replaced by the 21-story I.E. (now Alliant Energy) Tower, billed as "Iowa's tallest building" when finished in 1972. (Photo at right courtesy of George T. Henry, photo below courtesy of The History Center.)

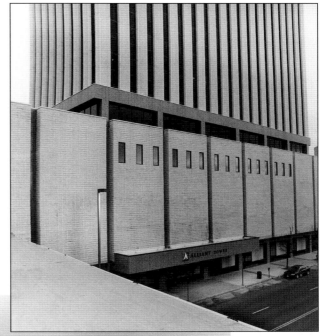

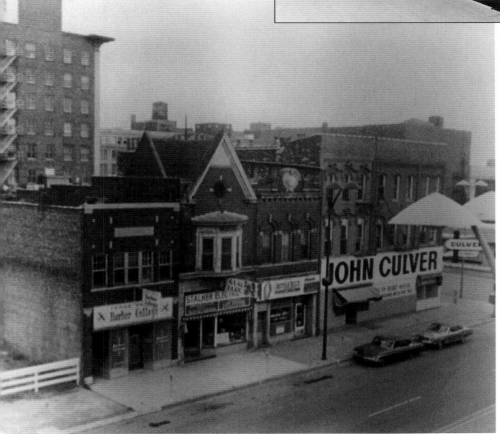

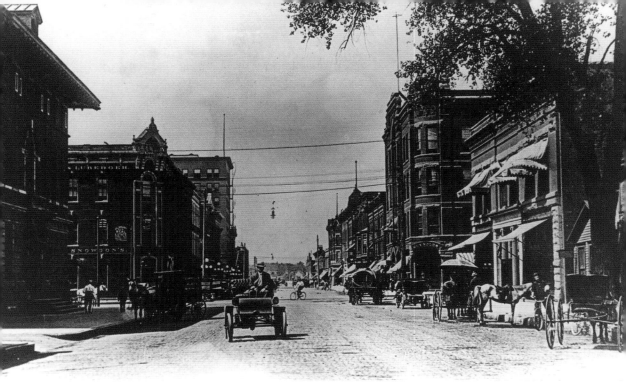

In about 1912 the Old Federal Building (on the near left) was new, located down Second Avenue SE towards the river. Beyond Third Street was the old Ely block, where a few automobiles were making their appearance. On the right corner past Third Street is the Kimball building, which burned in 1916. The 12-story Merchants National Bank was built in 1925 and 1926 where the Kimball building had stood. The Merchants Bank later became Firstar Bank, and at this time is US Bank. At the near right was the old Cedar Rapids National Bank building, which became Jack Yager's Clothing Store and was ultimately torn down in 1961 to make room for Merchants National Bank's parking ramp and drive-thru banking lanes. (Top photo courtesy of The History Center, bottom photo courtesy of George T. Henry.)

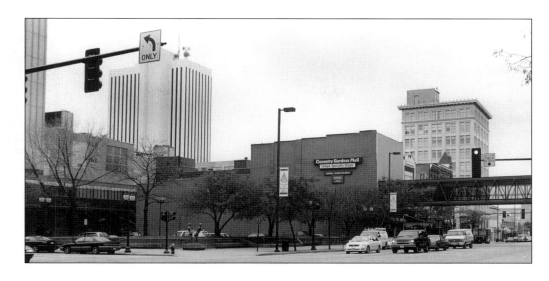

This 1880 corner structure was one of the buildings built on all four corners of this intersection at First Avenue and Third Street SE by the Waterhouse family. In 1913 Kresge's Dime Store opened and continued to be a constant presence here until 1969, even though the store was known in its last few years as the Jupiter Store. The Kresge store was extensively remodeled in the late 1950s when the upper two floors were removed. The structure was torn down in 1973 and replaced with the Merchants National Bank's "environmental" parking lot, an early example of landscape parking. (Top photo courtesy of George T. Henry, bottom photo courtesy of The History Center.)

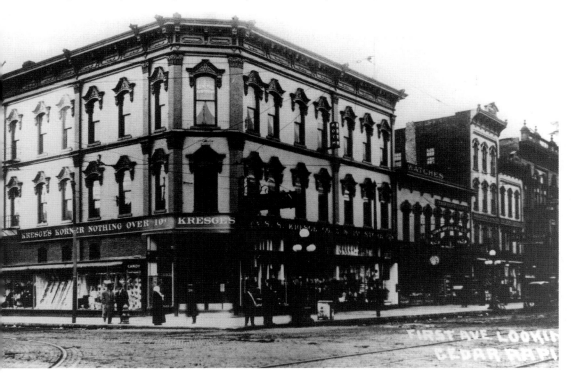

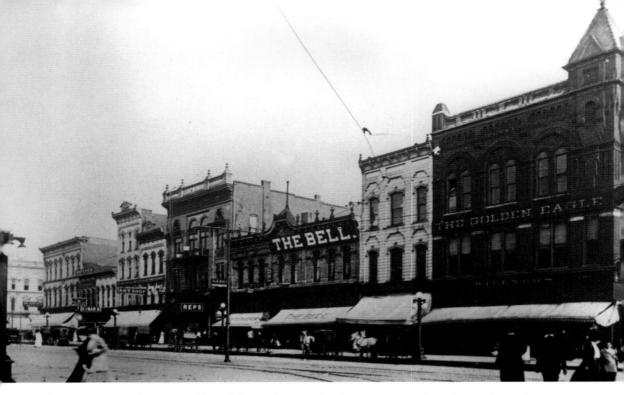

The area between Second and Third Streets SE on First Avenue has survived time quite well. On the corner is the Craft block, constructed in 1883. For several decades a popular clothing store, the Golden Eagle, operated here. During World War II, McLellan's Discount Store briefly occupied the store before moving to the Granby building. After the war, the structure was covered with metal siding and housed first Robinson's Store, and later, Slumberland. In 1983, the siding came down and the Craft block was restored to look very much as it had originally, thanks to local resident Frank Pfaff.

The Bell and Craemer's stores shared a building. Craemer's added a third story to their section. The Bell was later known as Syndicate Clothing, and now has been Gringo's Mexican restaurant since 1981.

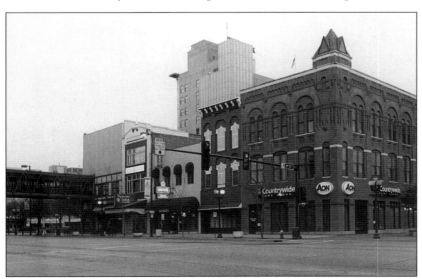

The building at left with the skywalk entering it is now Coventry Gardens Mall. The exterior is still covered with wall panels, but an 1897 facade exists underneath the covering. (Top photo courtesy of The History Center, bottom photo courtesy of George T. Henry.)

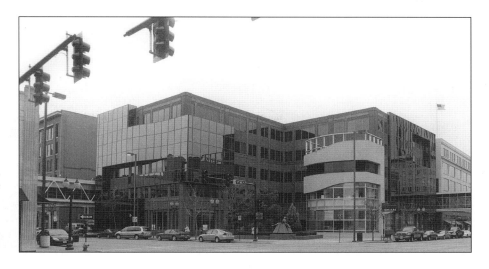

In 1905, the splendid new Third Avenue Hotel was constructed on the southwest corner of Third Avenue and Third Street SE. It was originally six stories high. Around 1920 a seventh floor was added. The hotel was later named the Montrose Hotel and was one of the first two fireproof hotels in Cedar Rapids. (The other was the Allison Hotel on First Avenue.)

On the right of the Montrose Hotel was the Wilcox building, which later became the home of Sanfords Store. At the extreme left of the photo is a portion of the old Second Presbyterian Church, later called Westminster Presbyterian Church. This building was torn down in 1916, and the church moved to its present location at Third Avenue and 14th Street SE. The Montrose Hotel operated until 1981 and then sat vacant until the summer of 1988 when it was torn down, along with the adjacent Wilcox Building (Sanfords) and the Old Security Bank building. For two years, this corner was a large gaping hole until the New Town Centre building was built in 1991. (Top photo courtesy of George T. Henry, bottom photo courtesy of The History Center.)

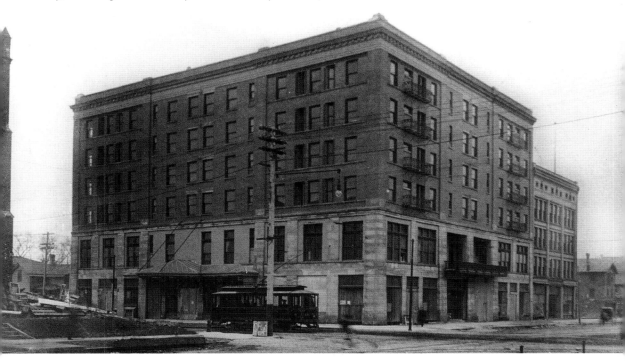

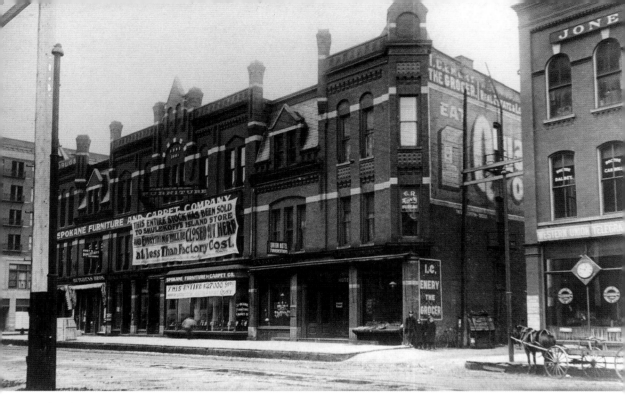

The elaborate Weller-Dows block was completed in 1885 on the west side of Third Street SE between Second and Third Avenues. It featured high chimneys and much Victorian detail. The large sign shown here announces the closing of the Spokane Furniture and Carpet Company, with the stock going to Smulekoff's Island Store.

The Weller-Dows block was built in three sections, separated by interior brick firewalls. The section at the corner of Third Avenue and Third Street was torn down in 1937 and replaced by a one-story Rexall Drug Store which stood for only 22 years. In 1959 that drugstore and the middle section of the Weller-Dows block were replaced by the new Armstrong's Department Store building, seen at the left. The former store has been refurbished and is now known as the Armstrong Centre, containing offices and businesses.

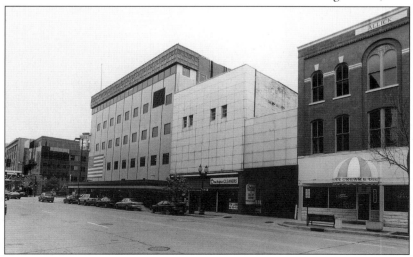

A surviving section of the Weller-Dows building is still covered with white square metal panels that were applied in the 1950s.

The Ely Annex at the right was restored by Deb Allick in 1997 to house Deb's Deli in the downstairs section. (Top photo courtesy of The History Center, bottom photo courtesy of George T. Henry.)

The Dows block was a three-story structure built in 1875 on the southwest corner of Second Avenue and Second Street SE. The old Cedar Rapids Post Office was located here until the old Federal Building was built at Second Avenue and Third Street SE during the 1890s. The old post office had a small side door on the right side of the building that A.B. George used for his shoe and boot business at the front.

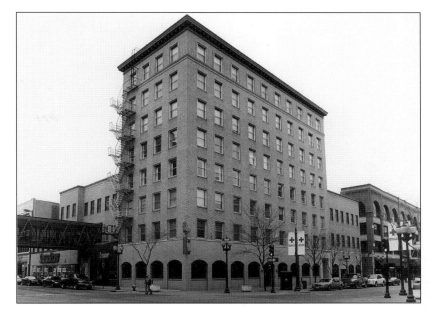

Dows family businesses (Iowa Electric Light and Power, Dows Maniti Dairy, and CRANDIC—Cedar Rapids and Iowa City Railway Company) have been located here throughout the building's history.

The Cedar Rapids Business College was located on the third floor until 1905.

In 1930, the entire corner section was demolished and replaced with the new eight-story Dows building. The remaining sections, both left and right of the 1875 building, were remodeled with new brick to match the new structure. Woolworth's "L" shaped store was partially replaced by the Osco drugstore in 1965, and Osco is still there in 2003. (Top photo courtesy of George T. Henry, bottom photo courtesy of The History Center.)

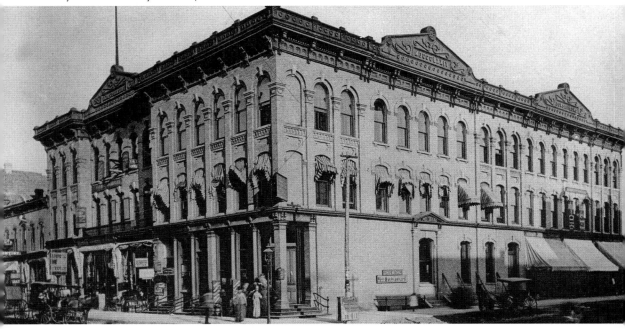

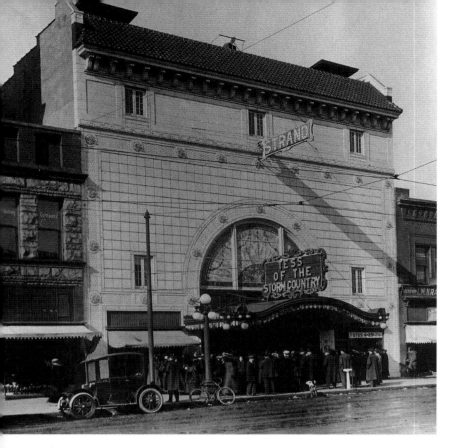

The movie theater on the north side of Third Avenue near the tracks opened its doors on October 18, 1915 as the Strand Theater. Its name was changed to the State Theater in October of 1929, and then to the New World Playhouse in 1960. It showed films until it was closed on October 16, 1981. The circular fixtures on the exterior formerly contained light bulbs. Over the past 20 years, the theater has served as a political campaign headquarters and most recently as a church, but most of the structure, including the balcony, has not been in use since the theater's closing.

It is interesting to note the crowd waiting to get into the Strand for the movie "Tess of the Storm Country" is seemingly all male. Other films shown there included such titles as "The Jazz Singer" (1927), the Cedar Rapids premiere of "Gone with the Wind" (1940), and "Ben Hur" (1960). (Top photo courtesy of The History Center, bottom photo courtesy of George T. Henry.)

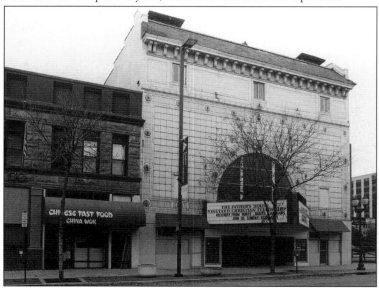

This small two-story building built about 1890 at 116 Third Avenue SE appears today much as it did over 100 years ago. It was originally used as a saloon by Frank Sindelar who lived upstairs with his family. It then became a barbershop owned by J.P. Green. An attempt was made to remove this building to facilitate the construction of the eight-story Higley Building to its right. The attempt failed and to this day the attractive little structure survives, surrounded by much taller buildings such

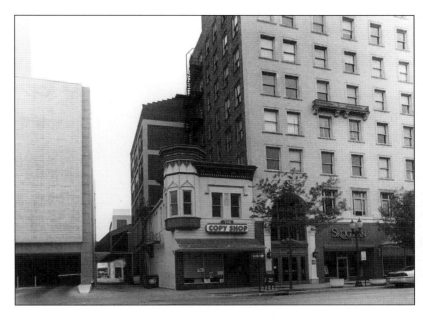

as the Alliant Energy tower to the left. The historic building is now used as a copy shop. (Top photo courtesy of George T. Henry, bottom photo courtesy of The History Center.)

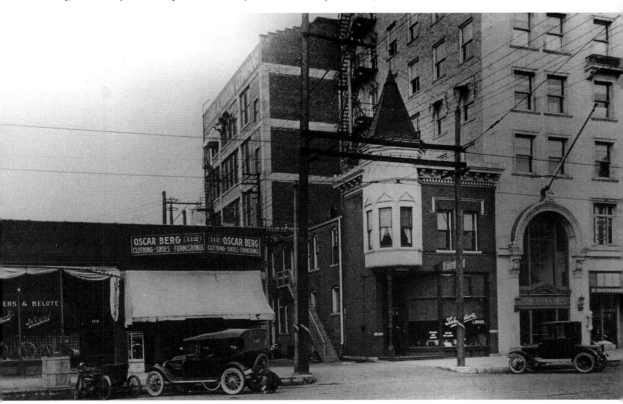

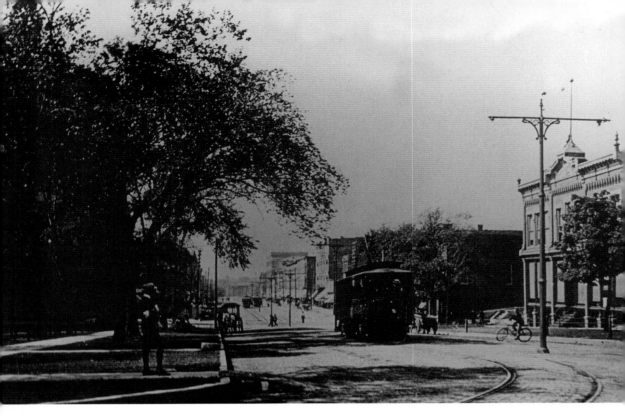

The streetcar tracks at the corner of First Avenue and Fifth Street SE about 1890 reveal the most prevalent mode of transportation at that time. Streetcars, horse and carts or buggies, as well as bicycles and one's own two feet provided the Cedar Rapidian the means to get from one place to another. The large building on the right corner is the J.S. Cook Dry Goods Building.

Today at the same corner, a much busier First Avenue is filled with six lanes of automobile traffic, and on the right corner the old Elk's Club is now the Chamber of Commerce headquarters. Farther down the street and on the other side of the railroad tracks is the Crowne Plaza Hotel (which is attached to the

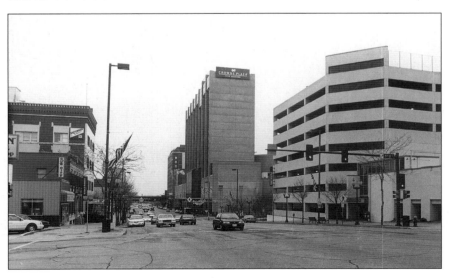

U.S. Cellular Center). Cedar Rapids is indeed fortunate that the early settlers laid out streets wide enough to handle the traffic of today. (Top photo courtesy of The History Center, bottom photo courtesy of George T. Henry.)

Chapter 2
CEDAR RAPIDS
CLOSE IN

By my own definition of what was downtown, I can now include these photos that I'll call "close in"—many of which will seem to be downtown locations and today they certainly are. Cedar Rapids' commerce area moved across the Fourth Street tracks and across the river. It expanded past Third Avenue and First Avenue. The businesses changed from one type to another, and there is still an active and productive downtown district there today.

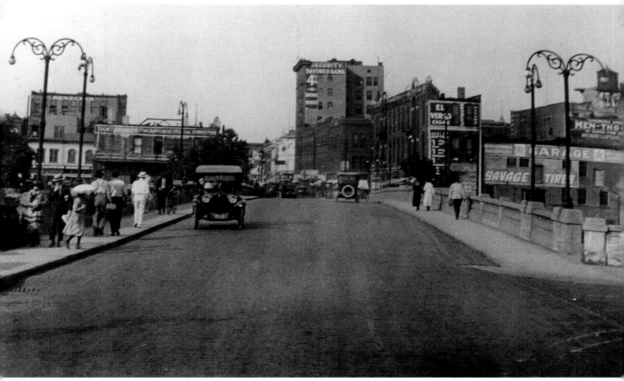

This pre-1930 view across the Second Avenue Bridge shows that more people were walking than driving at that time. (Photo courtesy of The History Center.)

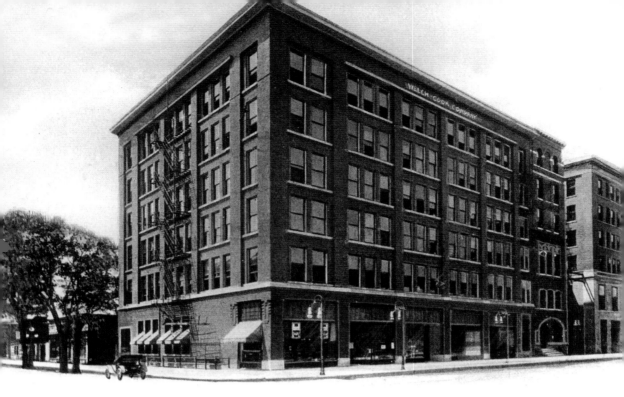

On the northwest corner of Fourth Avenue and Third Street SE stands a massive six-story structure that was built about 1908 for the Welch-Cook-Beals Company, wholesalers in dry goods, including farmers' overalls. The building was financed in part by Glenn Averill, head of the Cedar Rapids Gas Company, and as a result the Gas Company offices were on the first floor or sidewalk level of the building.

This was one of several structures built from 1905–1935 as part of a wholesale warehouse district, established directly south of the downtown area.

Collins Radio Company occupied the upper floors of the building following World War II. Today the building houses MCI WorldCom's telemarketing offices. (Top photo courtesy of The History Center, bottom photo courtesy of George T. Henry.)

Both of these pictures were taken from the second floor of the Hach building (401 First Street SE) and look east along Fourth Avenue from the First Street window.

In 1911, construction was beginning on the heavy-duty Laurence Press/Severa building across First Street from the Hach Building. To the right of the construction is the old Fay Brothers Lumber Yard, later known as Economy Lumber. On the left, the building with "Old Dutch Cleanser" on its side was Sam Shafer's Livery. Farther down the street is the six-story Welch-Cook-Beals building at Fourth Avenue and Third Street SE. It can still be seen today beyond the old Killian's ramp, at left in the background.

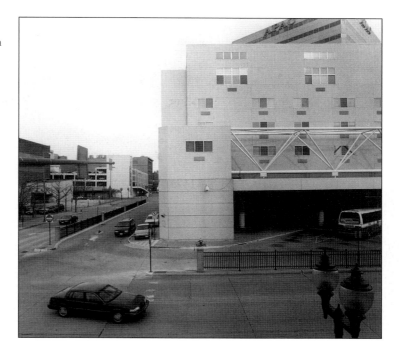

The Laurence Press Building was demolished in early 1982 to make way for the city's new bus depot. The apartments above the depot were added in 1989. (Top photo courtesy of George T. Henry, bottom photo courtesy of The History Center.)

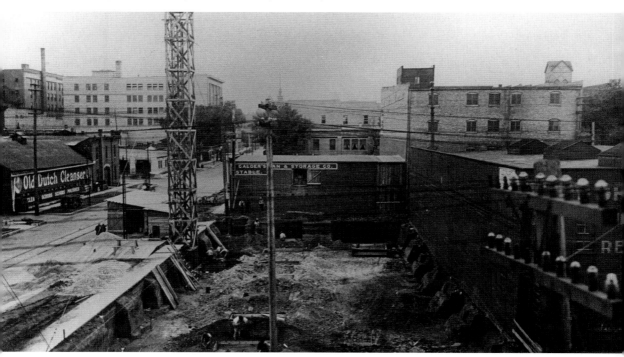

29

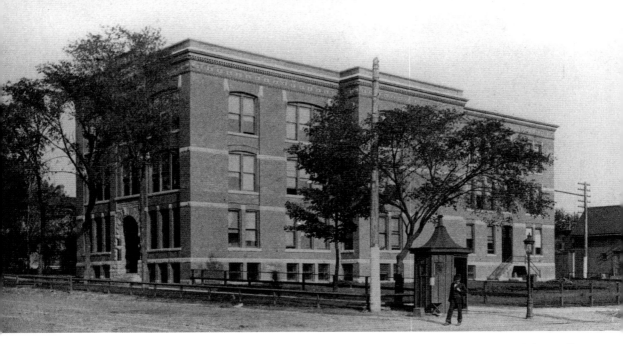

The old Burlington, Cedar Rapids & Northern Railroad and other railroad companies had their offices on the east side of the Fourth Street tracks at 411 First Avenue SE from about 1885 to the 1950s.

The building was originally 3.5 floors high, but another floor was added shortly after this picture was taken. The building was purchased for the Skogman Real Estate Company and "modernized" by covering the front with metallic panels and painting the brick yellow. Around 1980 the red brick was restored, and still visible near the top of the building are the letters "BCR&NRY." (Top photo courtesy of The History Center, bottom photo courtesy of George T. Henry.)

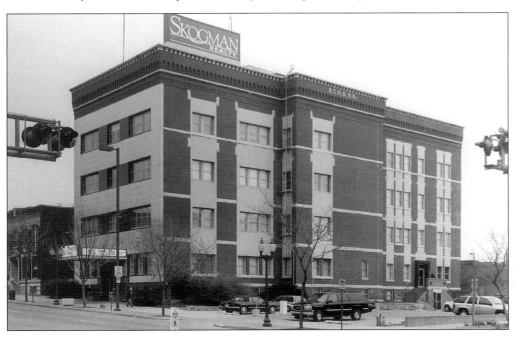

The BCR&N Railway Depot stood between Fourth and Fifth Streets and First and Second Avenues SE. The BCR&N Railway office building, which faced First Avenue SE, is visible behind the depot. The fourth floor of the BCR&N building had been added by this time, and the structure today looks much the same as it did then. A parking lot now occupies the site of the former depot. (Top photo courtesy of George T. Henry, bottom photo courtesy of The History Center.)

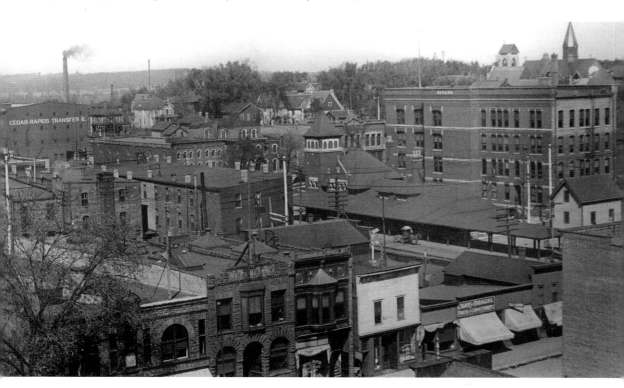

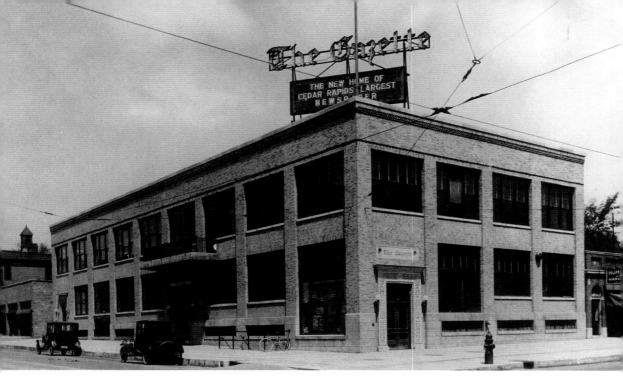

The *Gazette* newspaper was started in 1883 as the *Evening Gazette* at 87–89 First Avenue SE. It moved to its present location at Third Avenue and Fifth Street SE in 1925. This picture was taken shortly after that.

While there have been over 30 newspapers published in Cedar Rapids in its history; the *Gazette* is the only paper that survives today. The building has been updated and the entrance changed from Third Avenue to Fifth Street in the past 78 years. There has also been a large addition to the building on the Third Avenue side.

While the writing, editing, layout, and printing of the newspaper were originally all done in the downtown location, the printing operation has now been moved to a larger and more modern facility south of the city. (Top photo courtesy of The History Center, bottom photo courtesy of George T. Henry.)

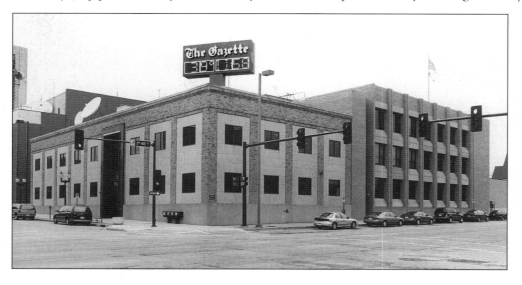

On the corner of A Avenue and Second Street NE, Robert Armstrong built the first modern parking ramp in Cedar Rapids around 1951. In connection with this ramp, which housed cars from the Roosevelt Hotel before the hotel built its own parking facility, was a service station run by Jack Hatt. The Jack Hatt Service was demolished in 1978 and replaced by an addition for more parking and rental space. (Top photo courtesy of George T. Henry, bottom photo courtesy of The History Center.)

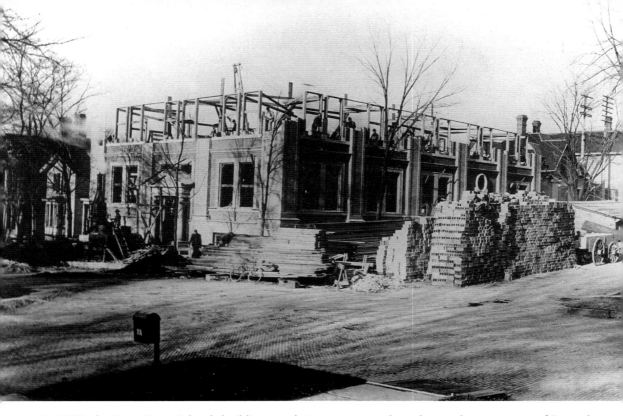

In 1905, the Inter-State Schools building was being constructed on the northwest corner of Second Avenue and Sixth Street SE. It was to be an adult business school and was in a residential area known as Mansion Hill.

The building later became the home of Inter-Ocean Reinsurance Company and the early homes of Millhiser Smith Insurance Company and the Teleconnect Company. It is currently used for the offices of the law firm Lynch Dallas PC.

Note existence of a mailbox in both photos. (Top photo courtesy of The History Center, bottom photo courtesy of George T. Henry.)

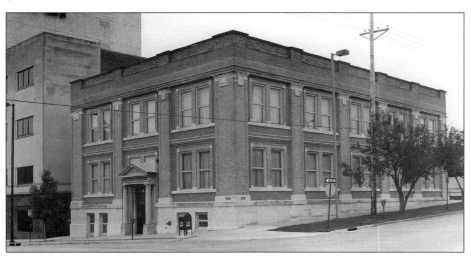

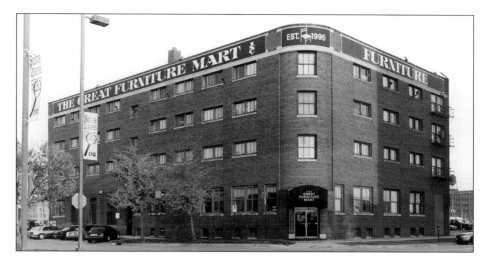

This building at 600 First Street SE has changed very little in appearance since it was built in 1915 for John Blaul & Sons Company Wholesale Grocers. A wholesale grocery, later known as Midwest Foods, operated from this building until the early 1990s.

After being extensively remodeled, it reopened in 1995 as the Great Furniture Mart. Soon this will be the only pre-1960 building still standing on the east side of First Street in downtown Cedar Rapids. The old Iowa Illinois Gas & Electric Company building, which is one block south, is scheduled to be torn down and replaced by a new federal courthouse in 2004–2005. (Top photo courtesy of George T. Henry, bottom photo courtesy of The History Center.)

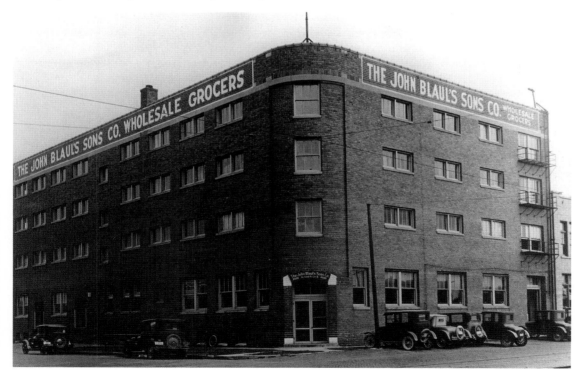

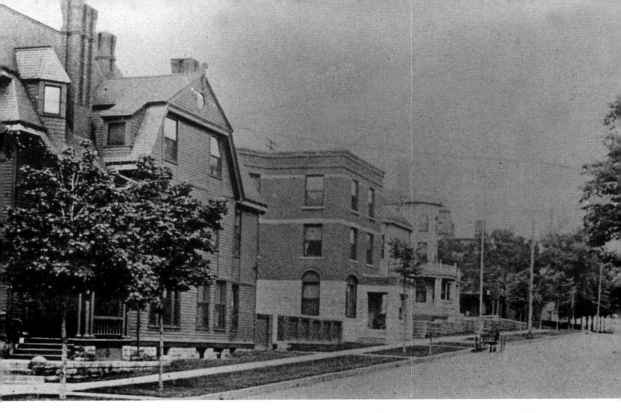

The stately houses and apartments on Seventh Street between First Avenue and A Avenue NE were once some of the finest mansions in Mansion Hill, the elite residential section of old Cedar Rapids. The large house at the left, the elaborate stone and brick brownstone apartment structure in the middle, and the old George Williams mansion on the right were all torn down.

In 1946 the George Williams mansion was replaced by a large automobile garage for Baxter Motors, still visible behind the Taco Bell restaurant. The houses closer to First Avenue were destroyed in the 1950s to make room for a used car lot for the Rapids Chevrolet Company. (Top photo courtesy of The History Center, bottom photo courtesy of George T. Henry.)

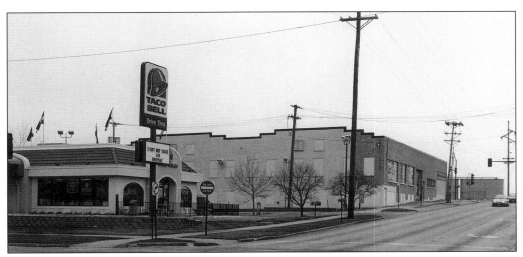

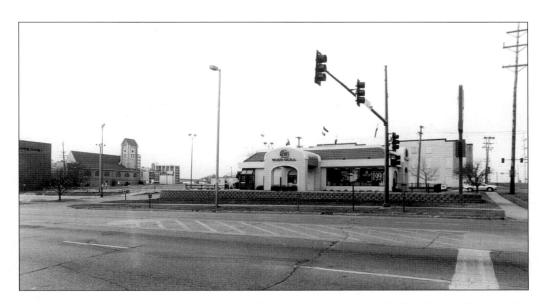

The car lot that was mentioned on the previous page has now come to pass. The block was cleared and is full of used cars. Also the garage that first belonged to Baxter Motors now proclaims itself to be the Chevrolet Truck Center. Taco Bell retains its spot on the corner. In the background at left is Grace Episcopal Church on A Avenue NE.

In the older photo, also note the old El Kahir Shrine Temple on A Avenue. (Top photo courtesy of George T. Henry, bottom photo courtesy of The History Center.)

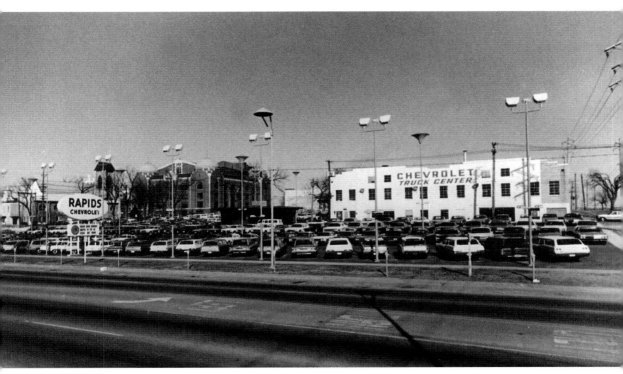

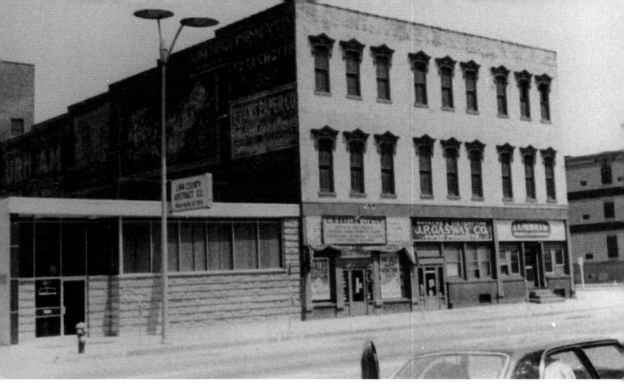

On First Street SE between Third and Fourth Avenues looking to the east is the three-story structure that was the original Witer Brothers Wholesale Grocery Warehouse, later an early home for the J.P. Gasway Company. At the far right is the Laurence Press building on the corner of Fourth Avenue and First Street SE.

On the left is the structure built for the Linn County Abstract Company in the 1960s that remains virtually unchanged. The three-story old Witwer warehouse is gone except for a common wall between the two. Smaller one-story structures were built in the 1970s to replace the warehouse. In the background towers the APAC building, constructed in 1983. (Top photo courtesy of The History Center, bottom photo courtesy of George T. Henry.)

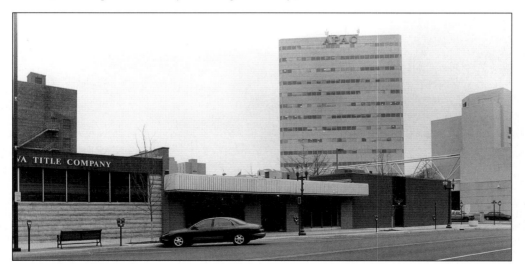

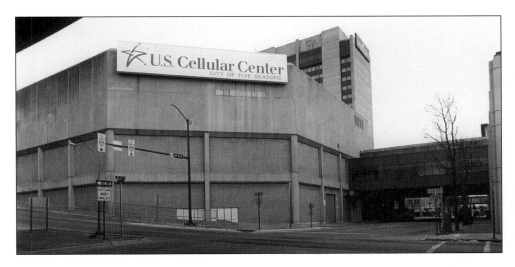

At A Avenue and Third Street NE, the very popular Danceland ballroom was located above the Tropic Lanes bowling alleys. The building was formerly a garage, with Danceland taking over the second floor. The entrance was from a long stairwell opening between the bowling alley and the surplus store on Third Street NE.

In 1973 this block was cleared to First Avenue, and four years later construction began on the Five Seasons Civic Center (now the U.S. Cellular Center) which was completed in 1978. Part of the arena covers a portion of the former Danceland site. At the lower left of each photo is the start of the A Avenue viaduct. (Top photo courtesy of George T. Henry, bottom photo courtesy of The History Center.)

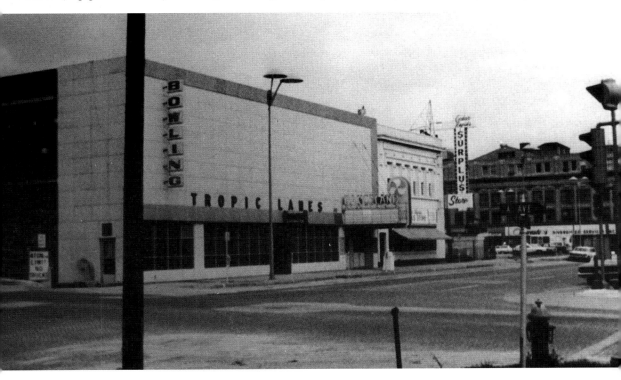

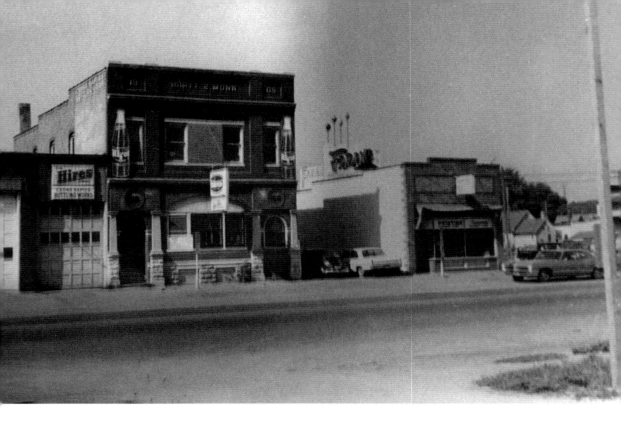

This two-story structure at 118–124 First Street NW is the old Cedar Rapids Bottling Works, manufacturers of a variety of soft drinks. For several decades they sold the "Hur-Mon" brand named after the original owners Arthur Hurtt and Charles Monn. The building to the right is McRaith's Ice Cream Shop. Although the two-story building is gone, the smaller structure at its rear that is now occupied by Mautz Paint was actually a later addition to the old Hur-Mon building. The former McRaith's is an extension of the paint store. (Top photo courtesy of The History Center, bottom photo courtesy of George T. Henry.)

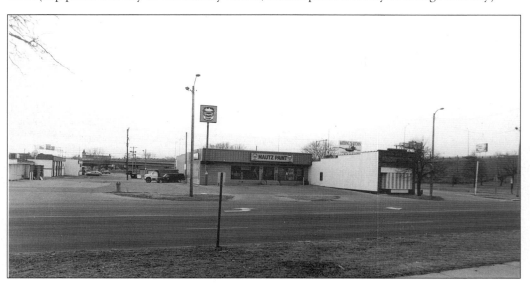

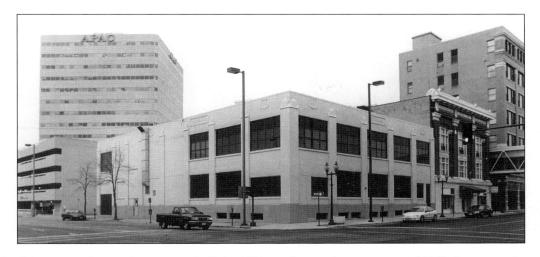

The Hutchinson Ice Cream Factory was built in 1920 on the northwest corner of Fifth Avenue and Third Street SE. The company moved there from their former location on H Street SW. Until the 1960s, this was a well-known corner, as people could walk by and look in the basement windows and actually see the ice cream being made. For many years, a Borden Ice Cream sign featuring Elsie the cow hung from the corner of the building, and the name "Hutchinson" can still be seen at the top. A small addition was added on the left side in later years.

After several years as an office facility, the building became vacant and was still unoccupied at the time this book was printed. (Top photo courtesy of George T. Henry, bottom photo courtesy of The History Center.)

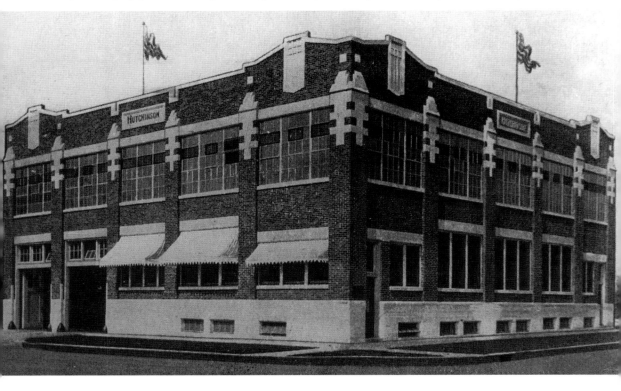

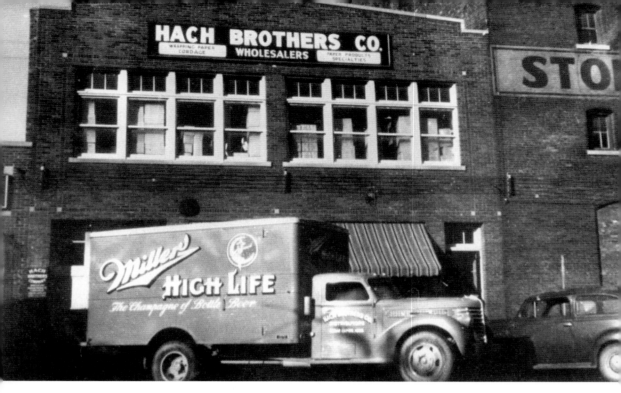

Around 1931 this building was built for Hach Brothers wholesale paper and beer distributorship at 415 First Street SE. It was part of the Warehouse District that was established between 1905 and1935. It ran from Fourth Avenue to Ninth Avenue and from the river to Fifth Street SE. It is hard to miss the beer truck parked in front of the store

In the early 1970s, Hach Brothers moved next door to the larger American Transfer building at 401 First Street SE. That four-story structure was built in 1899 for the Hamilton Brothers Wholesale Farm Machinery and Seed Company.

In 1978 the original Hach building was converted to a restaurant known as Mimms. Later the restaurant became Charlie's on the River, and now is Muddy Waters. The building to the left was the old Nash-Flodin Fruit Warehouse. It later became Killian's Carpet Warehouse and is now an annex to the

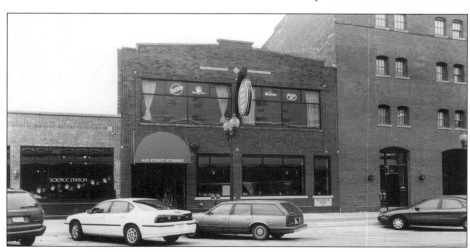

Science Station. (Top photo courtesy of The History Center, bottom photo courtesy of George T. Henry.)

The lower picture, taken about 1956, shows many signs, billboards, and small retail shops competing for attention. On the far right is the Taft Hotel, which also housed the Hall Bicycle Shop on the ground floor. Next are Chandler's Auto and Electric Shop, Art's Radio Doc, a small restaurant, and Dempsey's Cleaners. The taller structure is the 1903 Coffits' building, and the far building is a garage with a bowling alley upstairs. The Coffits' building was originally a confectionery and recreation parlor. These were all located on the south side of Second Avenue SE between Fourth and Fifth Streets.

In 1977, the Taft Hotel was demolished, and the Hall Bicycle Shop moved a few doors down to the Coffits' Building. In 1987, ten years later, the one-story shops were demolished to make space for a parking lot for the Cedar Rapids Museum of Art. The old auto garage has been the Tycoon bar since the early 1980s. (Top photo courtesy of George T. Henry, bottom photo courtesy of The History Center.)

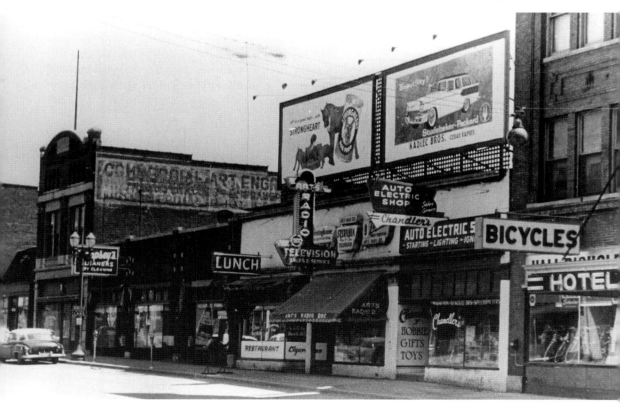

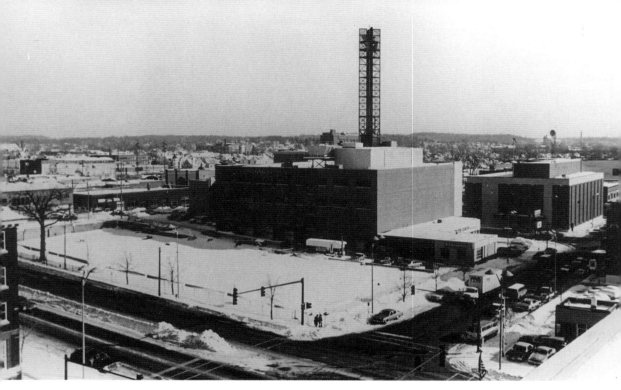

The Elks Club Lodge was built on the corner of First Avenue and Fifth Street NE across from the old YMCA in 1911. It replaced the Spangler house that had stood on that site. In 1960 a disastrous fire effectively destroyed the building. The Elks rebuilt at the same location and solved their parking problem by designing the new structure to accommodate parking on the roof. This changed in 1978 when the Five Seasons Parking Ramp, visible in the background, was built. The building now houses the Cedar Rapids Chamber of Commerce. (Top photo courtesy of The History Center, bottom photo courtesy of George T. Henry.)

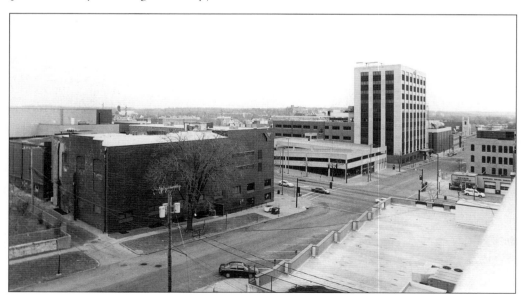

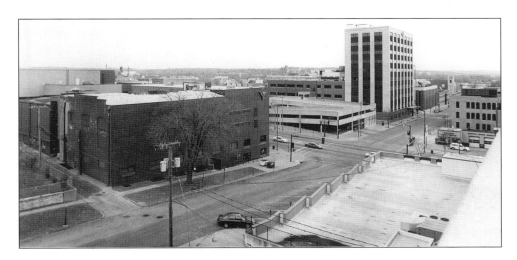

The lower picture is a view across First Avenue at Fifth Street NE about 1979. The Iowa National Parking Ramp had not yet been built nor had the 10-story office structure which was finished for Iowa National Insurance Company in 1981. The building now houses the offices of MCI WorldCom telecommunications corporation. The corner of the old YMCA is visible on the far left in the older photo, and the tall microwave tower in the center was built for Northwestern Bell Telephone Company in the early 1970s. The tower came down in 1993. The YMCA building was brought back up to code in 1979 and 1980 after some bricks fell from the building. Note the difference in the windows. The roof of the Old Elks Club, where parking was permitted, is visible on the right. (Top photo courtesy of George T. Henry, bottom photo courtesy of The History Center.)

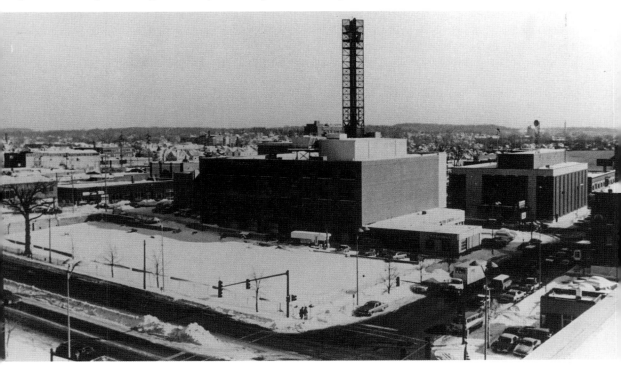

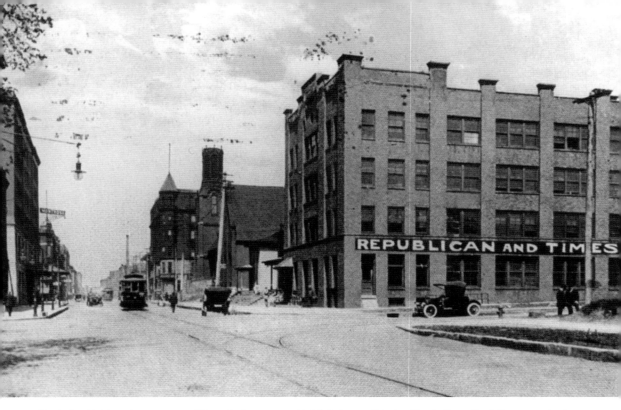

Built in 1907 at the corner of Fourth Avenue and Third Street SE, the Torch Press Building was the home of the Cedar Rapids *Republican and Times*, a competing newspaper that was absorbed by the *Gazette* in 1927. The building also housed the Torch Press Book Bindery and Book Shop, well-known throughout this part of the country. The Guaranty Bank was visible in the distant background, with the Second Presbyterian Church building between the other structures.

The Torch Press ceased operations around 1960. In 1966 the building was renovated and housed the Cedar Rapids Art Center until 1989 when the upgraded Cedar Rapids Museum of Art moved to its present location on Third Avenue SE. Today the Fourth Avenue building is again named the Torch Press and now houses offices. (Top photo courtesy of The History Center, bottom photo courtesy of George T. Henry.)

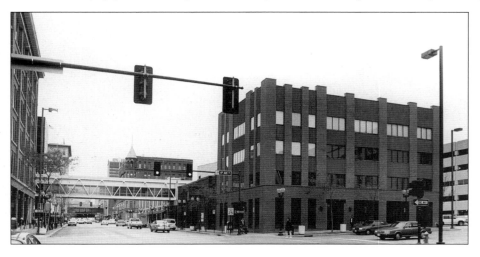

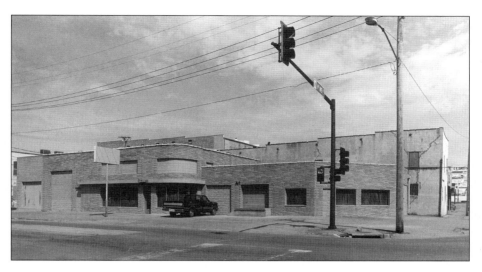

In 1956 Les and Larry's Phillips 66 Service Station stood on the northeast corner of Eighth Avenue and Third Street SE. It was adorned with billboards and had the most modern pop dispenser, a 7-Up cooler.

Since 1973 the old station has been used by Bills Brothers Freight and Salvage Furniture Company, first as their showroom and more recently as their warehouse. Most of the old service station windows and doorways are still in place. (Top photo courtesy of George T. Henry, bottom photo courtesy of The History Center.)

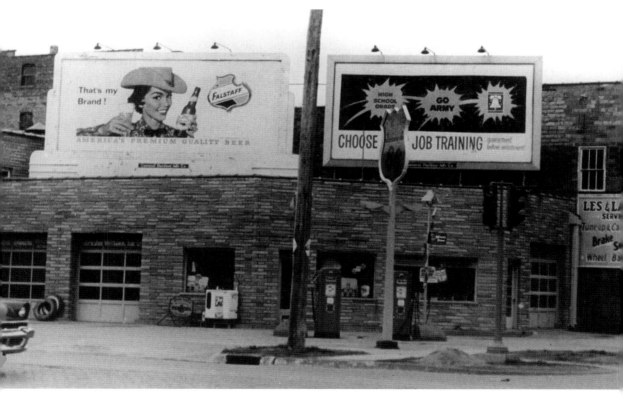

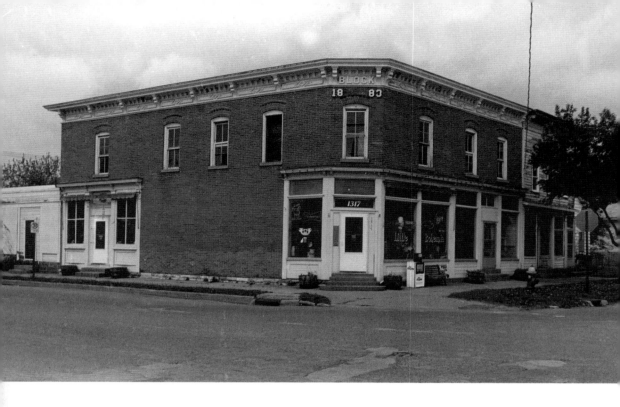

The Lesinger Block at 14th Avenue and Third Street SE was built in 1883 by the Lesinger family. When it was built, the wooden frame building to the right was moved from the corner to its present location in order to make room for the brick structure. The corner has always held a tavern and has been called "Little Bohemia" since 1937. It was close to Wilson's Packing Company and many Wilson workers stopped by to have a beer. The scene was captured in a 1944–1945 oil painting by Marvin Cone, art professor at Coe College from 1934 to 1960. Originally the middle door on Third Street was the entrance to Lesinger's Funeral Parlor. "Little Bohemia" is on the National Register of Historic Places. (Top photo courtesy of The History Center, bottom photo courtesy of George T. Henry.)

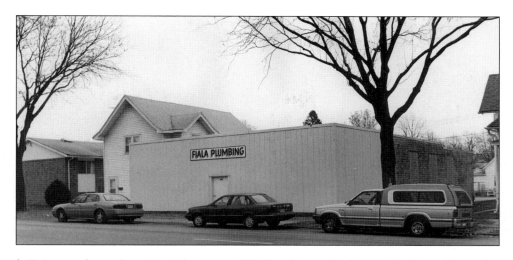

The Vondracek Dairy was located at 185 16th Avenue SW. The drivers lined up with their milk trucks here in the 1920s. Over the doorway was a sign that featured milk bottles carved in stone with the company name on a ribbon.

The old milk bottle sign is currently covered with metal siding, and Fiala Plumbing now occupies the building. (Top photo courtesy of George T. Henry, bottom photo courtesy of The History Center.)

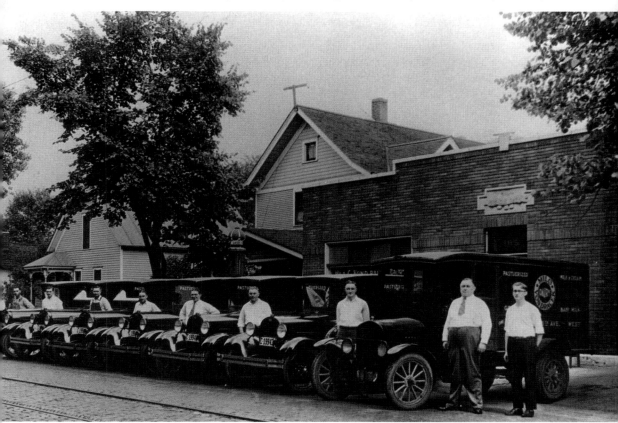

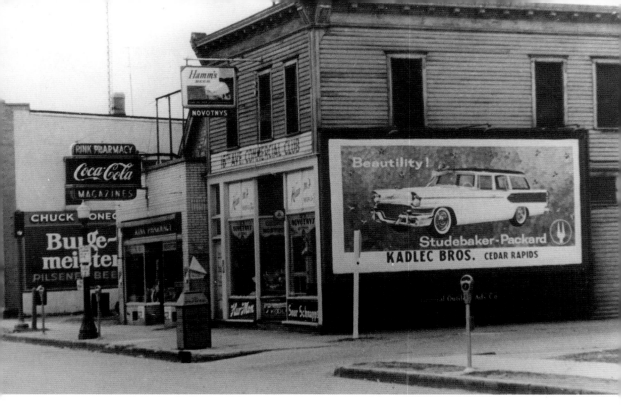

Sixteenth Avenue runs through the middle of Czech Village. The two-story building that housed the Commercial Club, a forerunner to the Czech Village Association, is at 16th Avenue and B Street SW and looks very much today as it did in 1956 when this picture was taken. The building was constructed in 1907 by John Viktor and also housed Novotny's Tavern. The billboard advertises Kadlec Brothers' Studebaker-Packard dealership, located a few doors down the street. To the left is the Rink Pharmacy, built in the 1930s.

Today a bandstand sits where B Street once was, and the front windows of the old 16th Avenue Commercial Club have been covered. The two buildings are connected and house the Czech Quarters Pub. The parking meters have been removed. (Top photo courtesy of The History Center, bottom photo courtesy of George T. Henry.)

On February 24, 1925, the Commonwealth Apartments and Hotel was under construction at 14th Street and Second Avenue SE. This special U-shaped complex was the finest apartment building in Cedar Rapids when it opened in 1926. Over the years it has also housed a restaurant, a beauty shop, and a massage parlor. It was billed as the city's "luxury" apartment building. In 1925, a parking garage for the Commonwealth was constructed across the alley, facing First Avenue. It later became the Times Theater

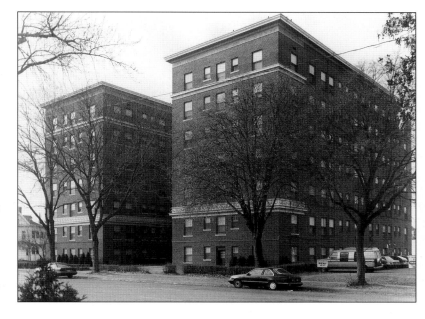

building in 1941 and was demolished in 1992. The Commonwealth still stands and is a credit to the city. (Top photo courtesy of George T. Henry, bottom photo courtesy of The History Center.)

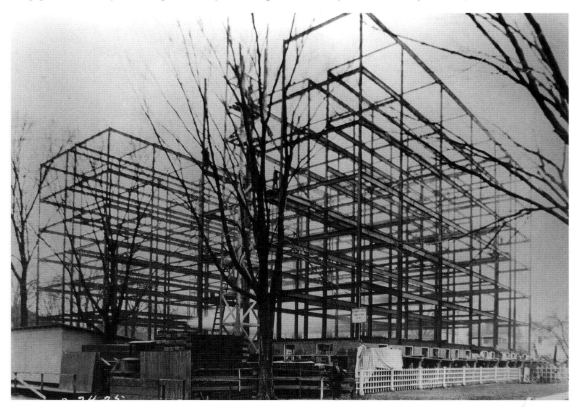

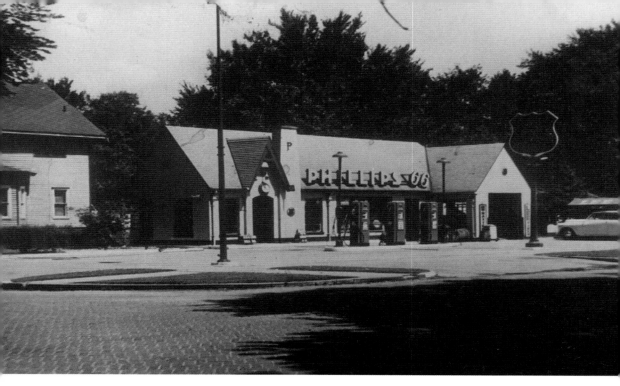

The old Phillips 66 Service Station was built on Second Avenue at Sixth Street SW. Second Avenue was the west side section of the Lincoln Highway in Cedar Rapids, and there were many service stations built on that street in the earlier days, both SE and SW. Today the station stands pretty much intact and its business is still related to automobiles. (Top photo courtesy of The History Center, bottom photo courtesy of George T. Henry.)

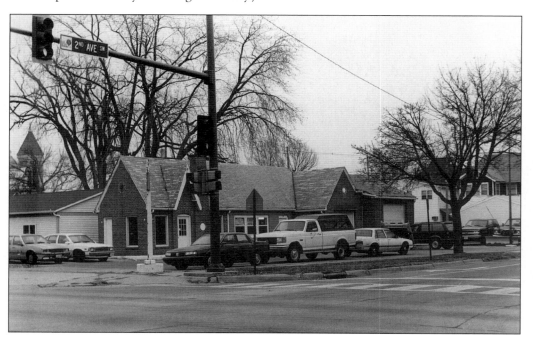

"The New Store," Jacob Oxley's new grocery store in the old town of Kenwood Park was established in the early 1900s. This building's original address was 119 First Avenue in Kenwood Park. Today the address is 3219 First Avenue SE in Cedar Rapids. Jacob Oxley was the postmaster of Kenwood Park, and

this store also served as the post office. There has been very little turnover in the building. By 1920 it became a barber shop and remained so for at least the next 30 years. In the late 1950s, a floor covering store was located here, known for many years as the House of Carpets. The building to the left was built shortly after the older picture was taken and housed the Kenwood Bakery for many years. Kenwood Park village was absorbed into Cedar Rapids in the late 1920s. (Top photo courtesy of George T. Henry, bottom photo courtesy of The History Center.)

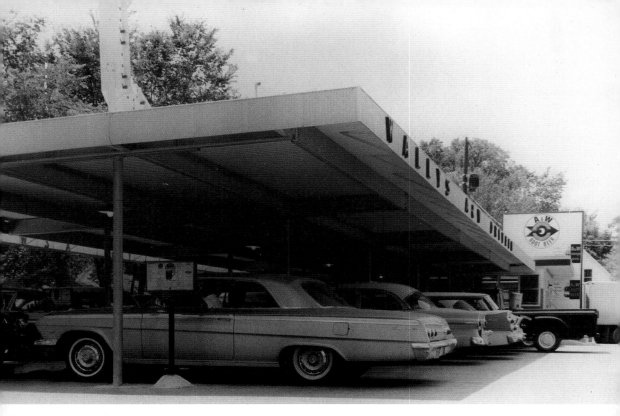

A drive-in restaurant established in 1958 is located at 1136 Ellis Boulevard NW and is still going strong. When it was built, it was called the Boulevard Drive-In. When this photo was taken in 1963, the restaurant was called Wally's, and today it is the A & W Family Restaurant. It has changed very little in the last 50 years, and it's still fun to drive in to have your favorite drink or sandwich served to you at your car window. (Both photos courtesy of George T. Henry.)

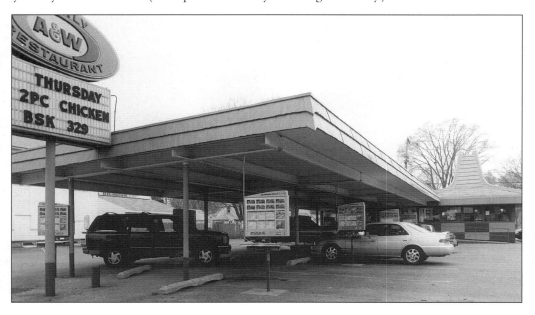

Naxera's Pastry Shop was added in front of one of the grand old houses on First Avenue SE, and there one could buy butter crust bread at 10¢ a loaf. It started business in 1935 on the "Avenue Strip" of businesses east of the downtown area. The building extension at 1539 First Avenue SE was

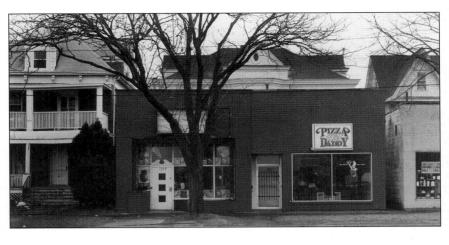

designed in unique Art Deco styling, which was popular in the 1930s. Naxera's operated there until 1957, when it was replaced by the Holland Home Bakery. The Holland Bakery closed in 1971. More recently, the building was occupied by Pizza Daddy. The left storefront has housed a variety of shops. The Art Deco façade was of a fragile glass type and was removed in later years. (Top photo courtesy of George T. Henry, bottom photo courtesy of The History Center.)

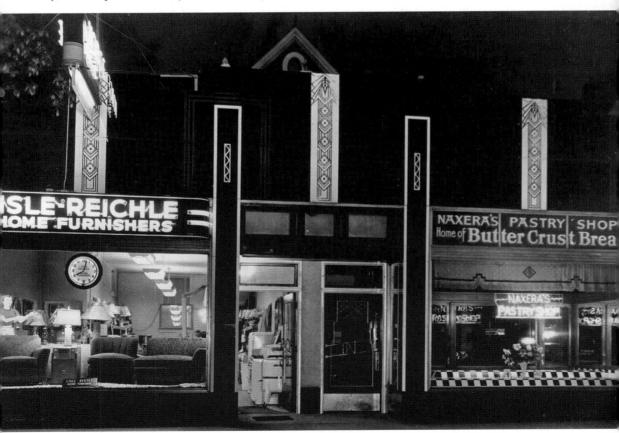

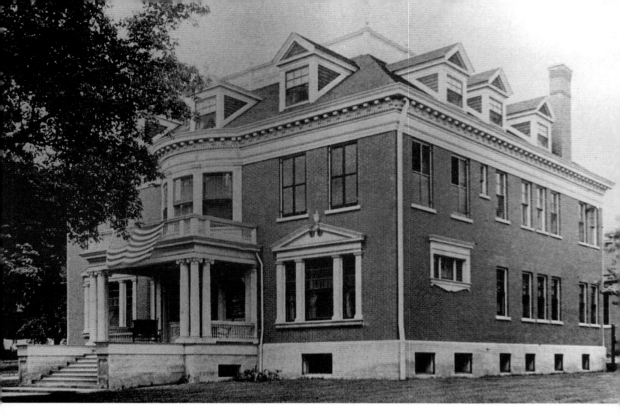

In 1897 this home at 800 Second Avenue SE was constructed for the George B. Douglas family in the Mansion Hill District. A few years after its construction, the home was "swapped" with the Brucemore Estate. The Sinclair family moved from Brucemore to the Douglas home and the Douglases moved to Brucemore. In 1924, the building became the John B. Turner Funeral Home and has remained as such for the last 80 years. Today the funeral home looks much as it did originally. It has had an addition attached to the rear and the side and a bay window constructed where the small frame window was. The small window was moved to the second floor front, however, and is there today. (Top photo courtesy of The History Center, bottom photo courtesy of George T. Henry.)

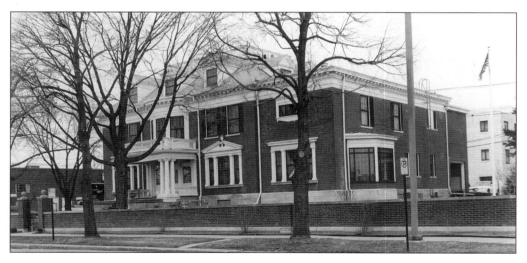

Chapter 3
BANKS

The earliest banking interests in Cedar Rapids were begun by several of the city's prominent families. Those included the Bevers, Elys, Van Vechtens, and Hamiltons. The early banks were located in simple storefronts, often within the building built by the families that owned the banks.

Beginning with the splendid six-story Cedar Rapids Saving Bank (now the Guaranty Bank) built in 1895 at the corner of Third Avenue and Third Street SE, banks built massive structures that defined the Cedar Rapids skyline. The Security Savings Bank was completed in 1908 (eight stories) and the American Trust and Savings Bank in 1914 (ten stories). The construction of large bank buildings culminated in the $1 million twelve-story Merchants National Bank (now the US Bank) in 1926.

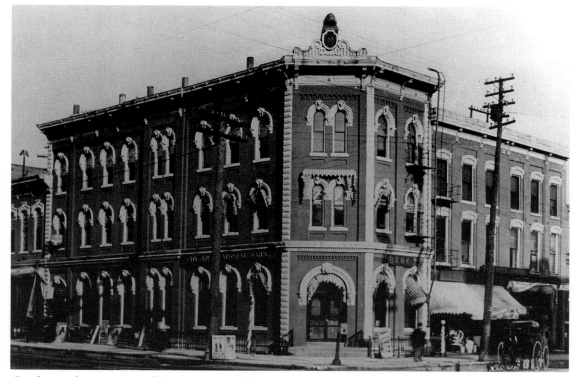

On the southeast corner of First Avenue and First Street SE was the Bever Building, site of Bever's Citizens National Bank, built in 1886 and torn down in 1956. (Note the "beaver" sculpture at the top corner of this building named for the "Bever" family.) (Photo courtesy of The History Center.)

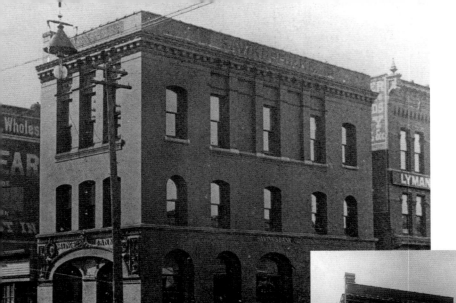

The original Security Savings Bank, built in 1893, sat on the corner of Second Avenue and Second Street SE. This brick structure was moved by pulleys to a new location one and a half blocks south and one block east to 319

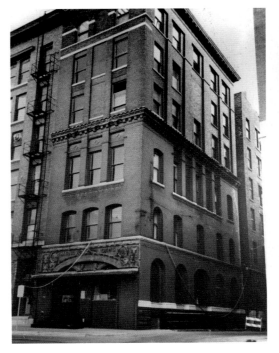

Third Street SE. It remained a bank, Perpetual Savings and Loan, until Perpetual relocated in 1957. Three floors were added around 1920, and a ramp was built between the bank building and the Montrose Hotel to provide extra room for the hotel. The addition was called the Montrose Annex. The bank building was torn down in 1988 and the site remains empty today. (Top two photos courtesy of The History Center. Photo at left by Mark W. Hunter.)

The new Security Savings Bank was built on the corner of Second Avenue and Second Street SE. It replaced the old bank building that was moved from that spot to 319 Third Street SE. At eight stories, the new Security building was the tallest structure in Cedar Rapids at that time. To showcase the building's height, light bulbs were installed along the top edge of the roof. They could be seen from miles away at night. Also unique is the circular staircase which is still there today.

During the 1930s, the bank was

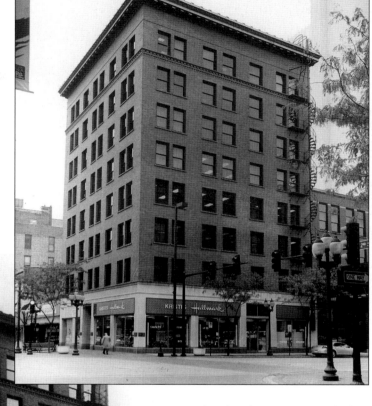

closed and never reopened. The first floor was lowered to sidewalk level and converted to retail business.

After World War II, the building was used primarily by Iowa Electric Light and Power Company until the company's new 21-story tower was constructed in 1972 on the same block. The light bulbs in the cornice still work, and in recent years have been lit between Thanksgiving and Christmas. (Top photo courtesy of George T. Henry, bottom photo courtesy of The History Center.)

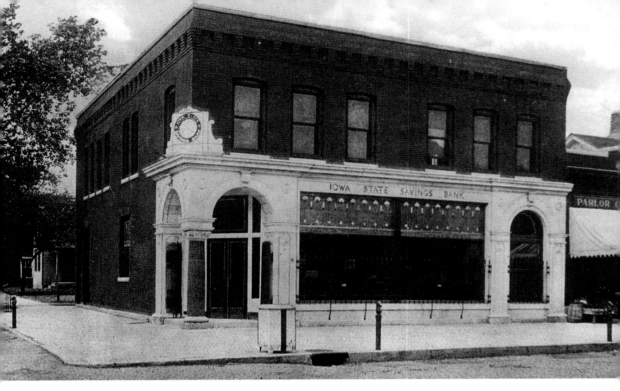

The old Iowa State Savings Bank at 12th Avenue and Third Street SE was originally known as the "South End Bank," serving the large Bohemian (Czech and Slovak) community south of the downtown area. It is a simple brick store building that was elaborately decorated on the street level to dignify itself as a bank structure.

Built about 1905, it was only used as a bank until 1917 when a larger building was built across 12th Avenue SE. The 1905 building became a grocery store for about 50 years and is now a printing shop. (Top photo courtesy of The History Center, bottom photo courtesy of George T. Henry.)

In 1895 the Cedar Rapids Savings Bank was constructed on the site where a Salvation Army Hall once stood. The bank was 120 feet long and only 40 feet wide and was the first building in Cedar Rapids to be over four stories high. At that time it was

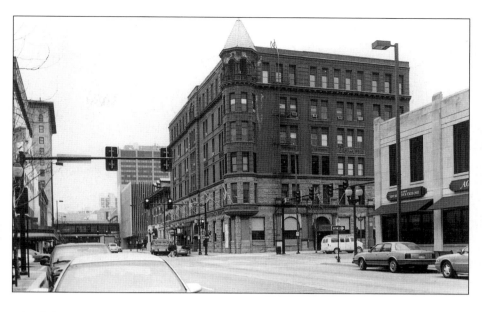

the largest pre–1900 bank building in Cedar Rapids and the first fireproof building of any size. It was designed by the popular Cedar Rapids architectural firm of Josselyn and Taylor. An addition was attached to the east side in 1909, and the building has housed the Guaranty Bank and Trust Company since 1934. (Top photo courtesy of George T. Henry, bottom photo courtesy of The History Center.)

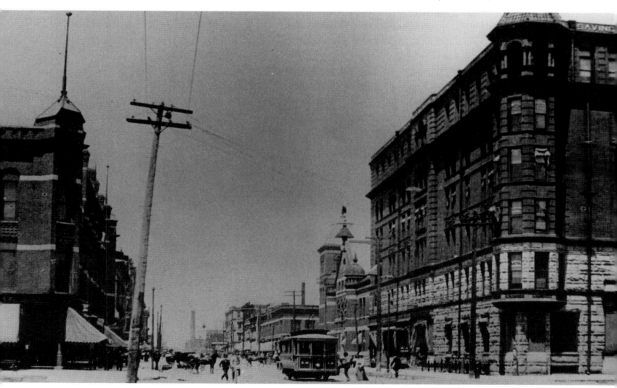

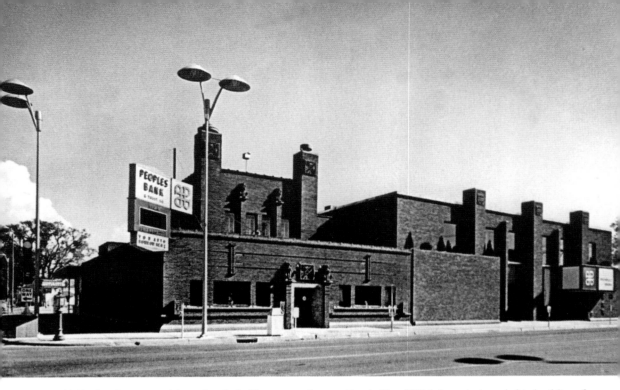

In 1910, the famous architect Louis Sullivan—teacher to Frank Lloyd Wright—designed this building for Peoples Savings Bank, which had begun operations in 1900. The original Sullivan structure on the corner of Third Avenue and First Street SW was completed in 1911. A two-story addition was made to the bank in 1966, and in 1978, two more stories were added to that.

The "West End Bank," as it was known in the early 1900s, has unusual gargoyles on the upper level of the building. In 1990 the bank was restored and now operates as a branch of Wells Fargo Bank. (Top photo courtesy of The History Center, bottom photo courtesy of George T. Henry.)

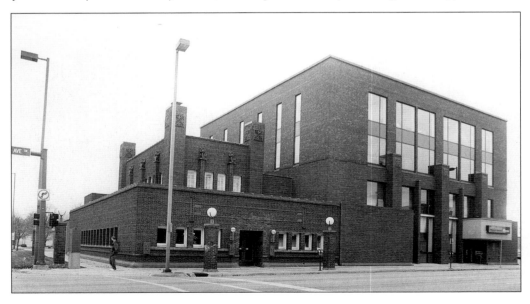

The Ely block on the southwest corner of Second Avenue and Third Street SE was constructed on the site of the original Ely family home and was built in 1881. It is the oldest intact business building

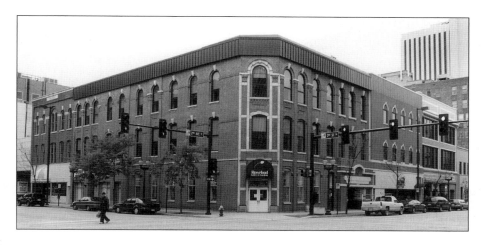

in downtown Cedar Rapids. Shortly after it was built, it became the home of the early Merchants National Bank and was occupied by that business until the bank moved across the street in 1916.

Later in 1925 the bank built a 12-story structure which was its home until it became Firstar Bank and more recently US Bank. Around 1950 the Ely Bank exterior was sheathed in metal siding, covering the ornate brick and limestone details, and remained this way until 1986 when the metal was removed, bringing the structure back to its 1881 appearance. The structure to the right became Martin's Dry Goods Store and was also covered with metal material. For many years the corner was occupied by the Belden Hill Cigar Store, and later by Patsy's Hat Shop. (Top photo courtesy of George T. Henry, bottom photo courtesy of The History Center.)

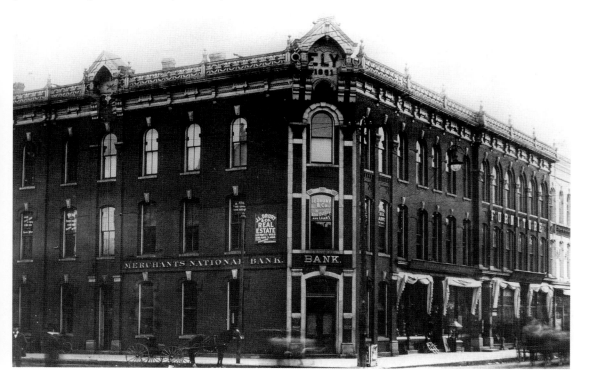

In 1863, the Higley block was built on the corner of First Avenue and Second Street SE. The old Higley building on the right was built shortly thereafter. The small building to the left housed the Cedar Rapids Times, a newspaper that began operations about 1880. Down Second Street was the first Farmers Insurance building, constructed about 1884, and then the Magnus block built about 1885. These last two buildings came down when a J.C. Penney's store was built in two phases in 1930 and in 1940. (Top photo courtesy of The History Center, bottom photo courtesy of George T. Henry.)

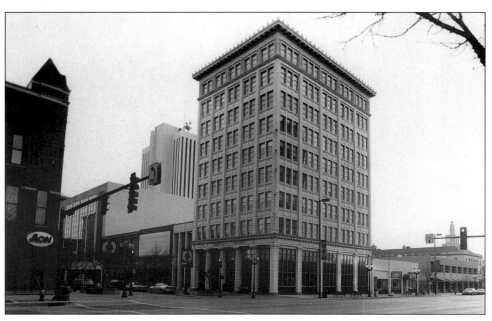

Chapter 4
SCHOOLS

Good schooling has always been important in Cedar Rapids. There have been marvelous schools here, starting with the grade schools, through the high schools, and on through college. There have been business schools and vocational schools, as well as four-year liberal arts colleges and a community college. The people of Cedar Rapids have looked to the future and taken care of the needs of a growing city through bond issues and private investment.

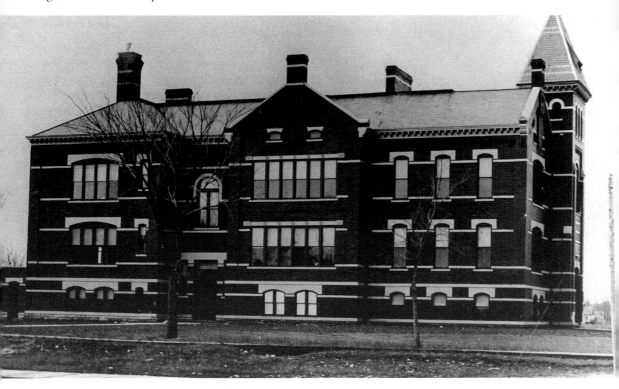

Van Buren School, built in 1884, stood at what was then the end of town at 14th Avenue between Third and L Streets SW. Until Wilson School was built, this was a grade school as well as a junior high school. The building was closed in 1970 and the land cleared the next year to make way for construction of the I-380 freeway. (Photo courtesy of The History Center.)

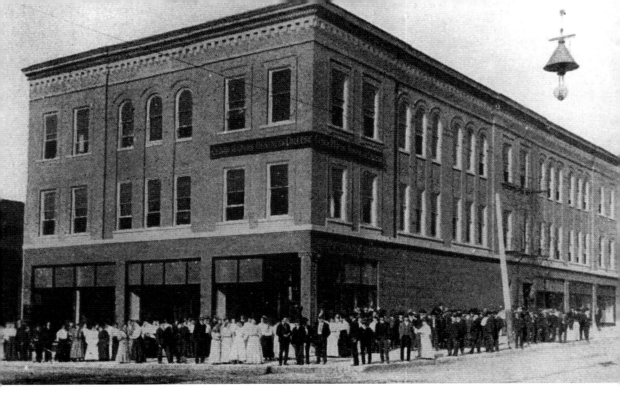

The Palmer Building at Second Avenue and Fifth Street SE was built in 1905 for A.N. Palmer's Cedar Rapids Business College. Palmer developed and taught the Palmer Method of Penmanship that was used for many years in more than 80 percent of U.S. schools.

The Palmer name is still visible at the top of the building. In later years the upstairs rooms of the structure were used by the El Kahir Shrine Temple. The first floor of the building was extensively remodeled in 1988 for the Teleconnect Company and later for MCI WorldCom telecommunications corporation. (Top photo courtesy of The History Center, bottom photo courtesy of George T. Henry.)

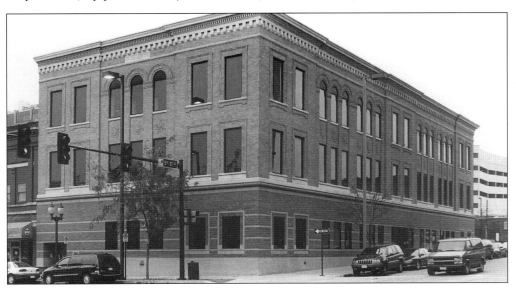

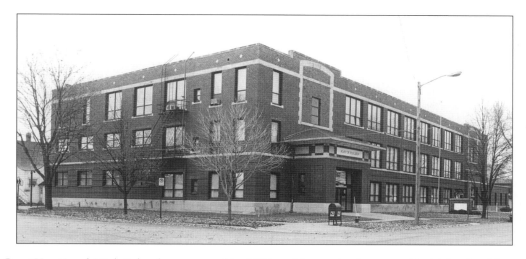

The old Grant Vocational High School was opened in 1915, and it was the first west side high school in Cedar Rapids. Grant School was closed in 1935 when additions were made to Wilson and Roosevelt Junior High Schools to convert them to combination junior-senior high school buildings.

In 1940 the old Grant School was converted for the use of the Board of Education, and the school district's administrative offices are still there today at 346 Second Avenue SW.

The building has changed little in appearance, although the entrance on the right has been removed. Even the fire escape and the fire hydrant are still in place. (Top photo courtesy of George T. Henry, bottom photo courtesy of The History Center.)

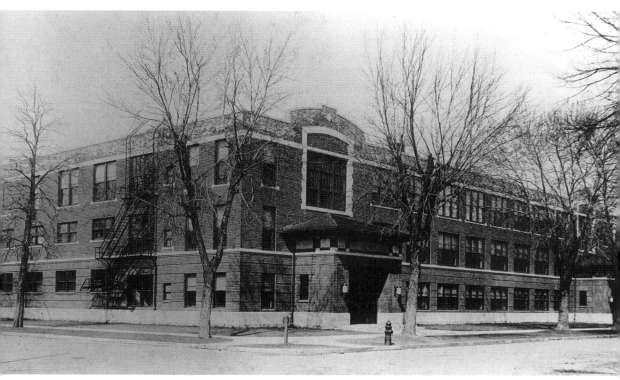

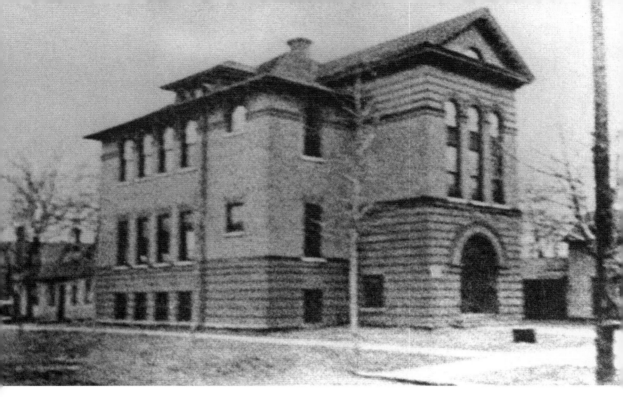

The Old Czech School was located at Second Street and Tenth Avenue SE. It was built in 1901 for a Czech language school that had been operating in Cedar Rapids since the 1880s. It was located one block west of the city's Monroe School, which also served a large percentage of the Czechs and other immigrant people. The school operated in this facility until 1950 when classes were moved to Hayes School and later to Wilson School.

In 1950 the old Czech school was converted to a sausage factory by Robert Kapoun and Andrew Polehna. Today it is still used as a food preparation facility. A small storefront was added to the building, as was the rear addition. The garage at right was originally a service garage for the Mitvalsky Fur Company.

The Czech school is the oldest surviving school structure in Cedar Rapids, public or private. (Top photo courtesy of The History Center, bottom photo courtesy of George T. Henry.)

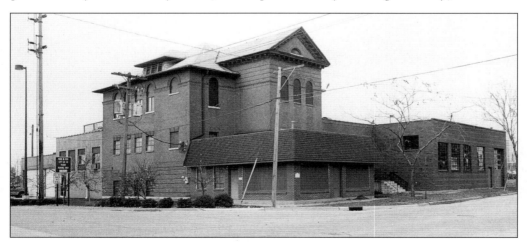

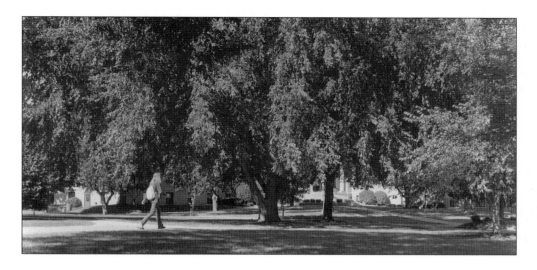

Greene Hall at Coe College is a great example of what can happen in 50 years. When the building was constructed in 1938, it was on a parcel of land that had no trees. Landscaping was not a foremost thought as the buildings were built. World War II came along, and afterward, flocks of veterans became students under the GI Bill. In 1956, when this picture was taken, there was nothing but lawn. It was a great place to play touch football or softball but was barren of trees. Shortly after this photo was taken, trees were planted, and today Coe has a campus of beautiful trees. The later picture was taken from the same viewpoint as the earlier shot, but aside from a peek through the branches at the pillars on Greene Hall porch, it is hard to see the building for the plentiful trees. (Both photos courtesy of George T. Henry.)

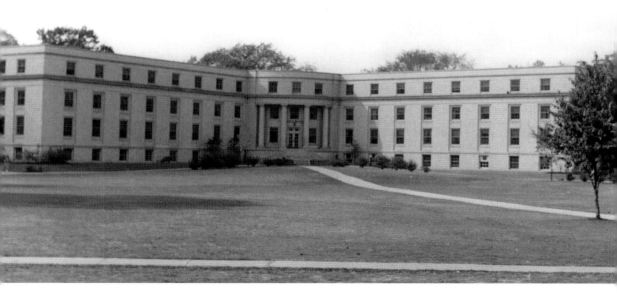

Only a few years ago, the east side of Center Point Road NE was cluttered with decaying houses and small businesses. Coe College was fenced-in near a less-than-attractive area. Between 1997 and 1999, a total of 27 homes and commercial businesses were removed by Coe to expand the campus to the east and across College Drive, as the street is now called. New brick student apartments have been built with lots of green space around them. In the background on the far left is Clark Racquet Center, which was dedicated November 29, 1989, and was the first building constructed on Coe's east campus. (Both photos courtesy of George T. Henry.)

Chapter 5
CHURCHES, HOSPITALS, AND MUNICIPAL BUILDINGS

Cedar Rapids has always had an abundance of churches. When the first settlers came, they built churches. As Cedar Rapids developed, so did the churches. Early on when churches were being built on Fifth Street SE, soon called Church Row, it was feared that people wouldn't attend churches if they were located so far out of town. Since then, a few of the churches stayed in their original locations, but many have moved farther out. Most have expanded, and a few have fallen by the wayside.

The old Second Presbyterian Church, at the southeast corner of Third Avenue and Third Street SE, was built about 1870. The building was abandoned in 1904 when the church, then named Westminster Presbyterian, built a new structure at Third Avenue and 14th Street SE. The older church building was used for feed storage and torn down in 1916. (Photo courtesy of The History Center.)

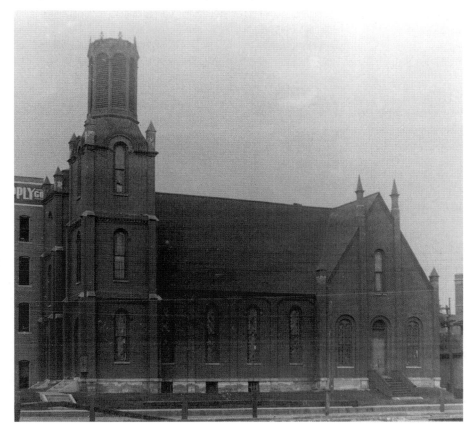

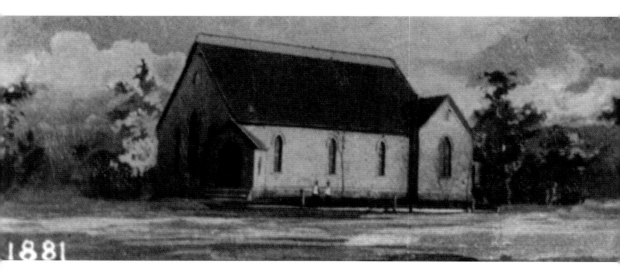

1881

The First Congregational Church was first located on the southeast corner of Second Avenue and Fifth Street SE. It was a small frame church building built in 1881 and was moved twice to other locations in Cedar Rapids to serve two other congregations. In 1884, the church added a parsonage that was 9 feet wide, 40 feet long, and 3 stories high. In 1887 a new stone church was built on the location of the first church. It was dedicated November 14, 1889. In 1926, the church was crowded out of downtown and traded land at 17th Street and Washington Avenue SE for the downtown property. Mr. E.W. La Plant was paid $1 by the church and he in turn paid the church $26,000 for the old church site. (Photos courtesy of the First Congregational Church.)

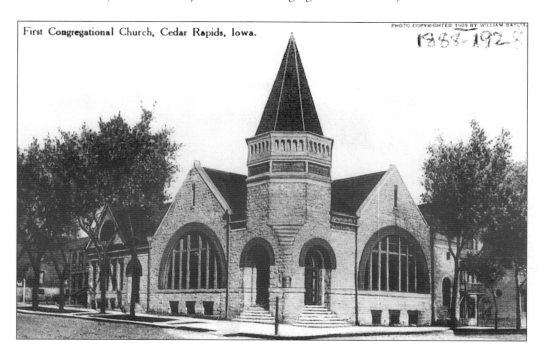

First Congregational Church, Cedar Rapids, Iowa.

PHOTO COPYRIGHTED 1909 BY WILLIAM BAYLIS

1888-1928

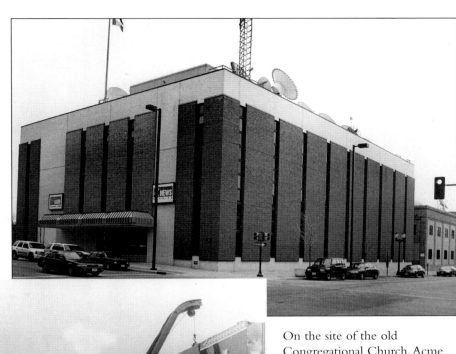

On the site of the old Congregational Church, Acme City Service built a gas station in 1928 when the old church was demolished. It was interesting that the station had a church-like tower on the building. In 1973–1974 KCRG Television and Radio Company built their broadcasting facility where the gas station had been, and is now operating on that site. (Top photo courtesy of George T. Henry, bottom photo courtesy of The History Center.)

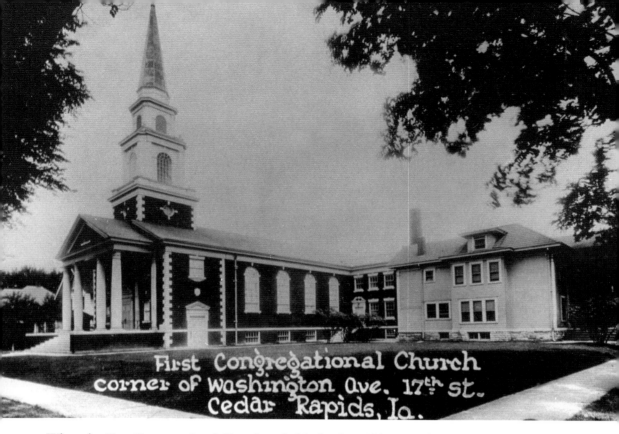

When the First Congregational Church traded its land at Fifth Street for the land at 17th Street and Washington Avenue SE, they began worshipping in the church house, at the right of the picture, while the main church structure was being completed. In 1958 an education unit was built, housing classrooms, offices, youth rooms, and a small chapel. Today the church stands as it did in 1958 when the education addition was completed. (Top photo courtesy of the First Congregational Church, bottom photo courtesy of George T. Henry.)

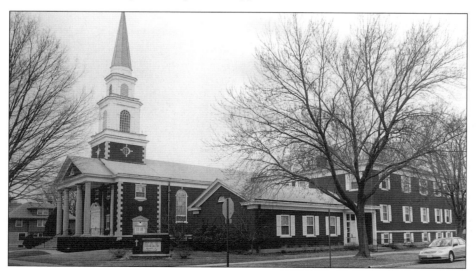

The First Presbyterian Church at Fifth Street and Third Avenue SE has stood the test of time. It was built at this location in 1867 and is the oldest intact church in Cedar Rapids that is still in use. It is of a Medieval Gothic design and has stood across from Greene Square Park in downtown Cedar Rapids for close to 140 years with only slight modifications.

When the church was constructed, many thought it was too far outside the center of the city to be successful. The education building to the right of the church was built in 1917 and replaced by a new structure in 1961. (Top photo courtesy of George T. Henry, bottom photo courtesy of The History Center.)

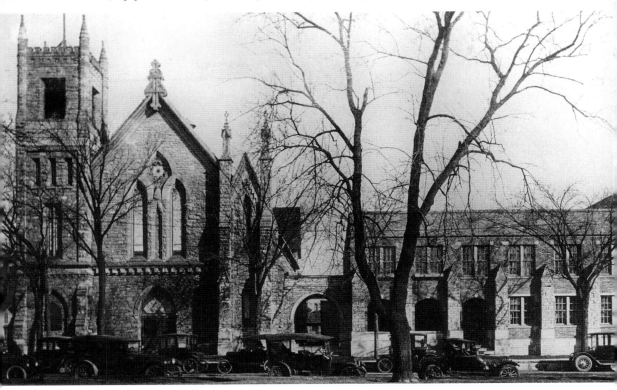

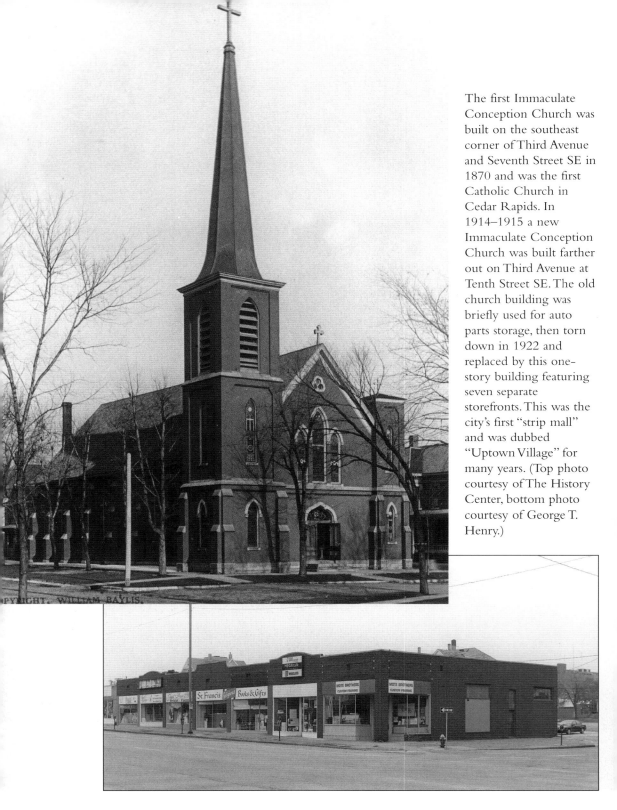

The first Immaculate Conception Church was built on the southeast corner of Third Avenue and Seventh Street SE in 1870 and was the first Catholic Church in Cedar Rapids. In 1914–1915 a new Immaculate Conception Church was built farther out on Third Avenue at Tenth Street SE. The old church building was briefly used for auto parts storage, then torn down in 1922 and replaced by this one-story building featuring seven separate storefronts. This was the city's first "strip mall" and was dubbed "Uptown Village" for many years. (Top photo courtesy of The History Center, bottom photo courtesy of George T. Henry.)

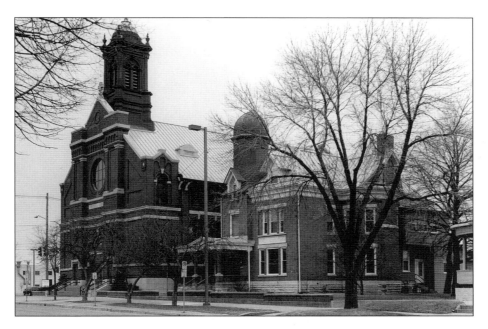

This was the residence of John Thomas in 1887. He was president of the Cedar Rapids and Marion Telephone Company and was also a wholesale dealer in leather saddlery and hardware. The church was built in 1915 and at that time the house became the rectory. Today the rectory looks much like it did in 1886. (Top photo courtesy of George T. Henry, bottom photo courtesy of The History Center.)

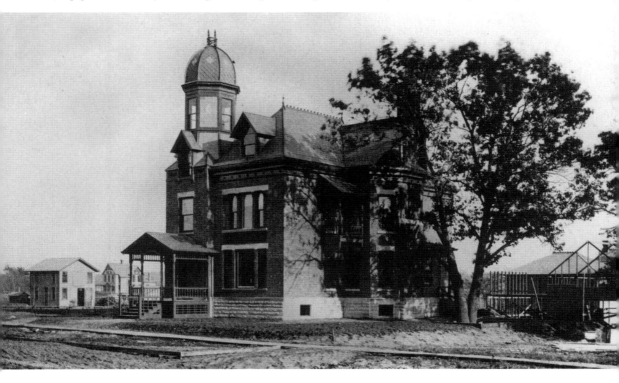

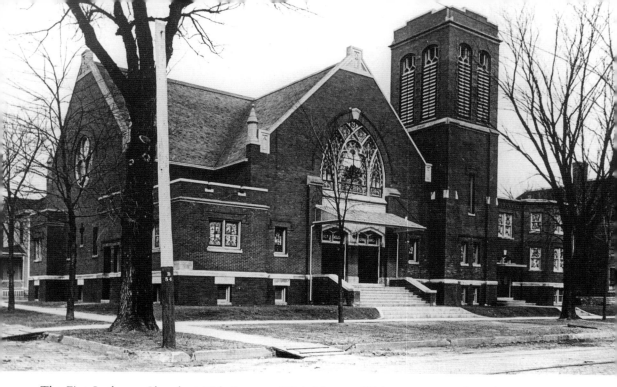

The First Lutheran Church at 10th Street and Third Avenue SE is catty-corner from the Immaculate Conception Church. After moving to several locations in the downtown area, the First English Lutheran Church was built in its present location in 1910. At that time 10th Street and Third Avenue was a quiet residential intersection. A few years later the Lincoln Highway was routed down 10th Street, and the downtown quickly expanded toward the church.

The First Lutheran Church has expanded several times. The most notable change was the relocation of the front entrance, when the steps and the front door were moved to the right and replaced with a large glass window in 1958. The most recent addition was completed in 1996. (Top photo courtesy of The History Center, bottom photo courtesy of George T. Henry.)

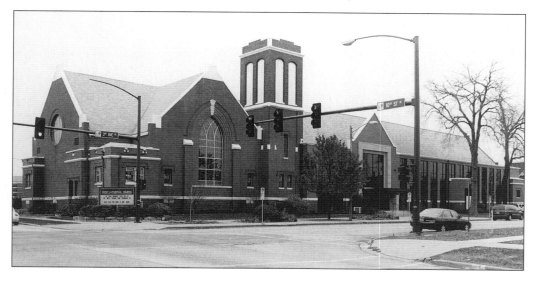

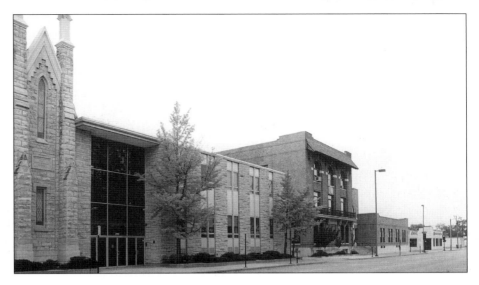

"Church Row," as it was called, was between Second and Fifth Avenues on Fifth Street SE. Here is a part of that row about 1915. On the left is the First Presbyterian Church Chapel, and the YWCA building, built in 1911–1912, is in the center. To the right of the YWCA are the old Saint Paul's Methodist Church and the old First Christian Church, with Fourth Avenue separating the two churches at Fifth Street SE.

The old Presbyterian chapel was replaced by the church education building in 1917. The YWCA building is still there, but St Paul's church building was demolished in 1920 and relocated to the Wellington Heights neighborhood. An addition was made to the YWCA to fill the spot left by St. Paul's. The old First Christian Church was also relocated and the old building torn down. (Top photo courtesy of George T. Henry, bottom photo courtesy of The History Center.)

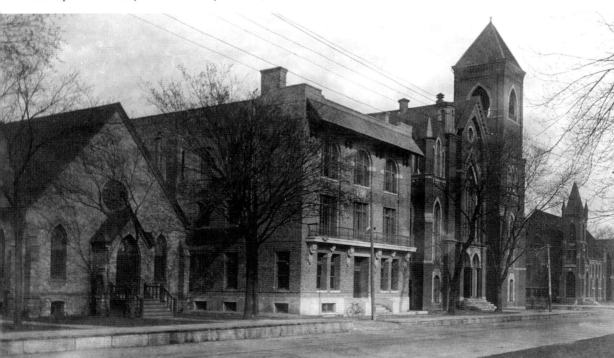

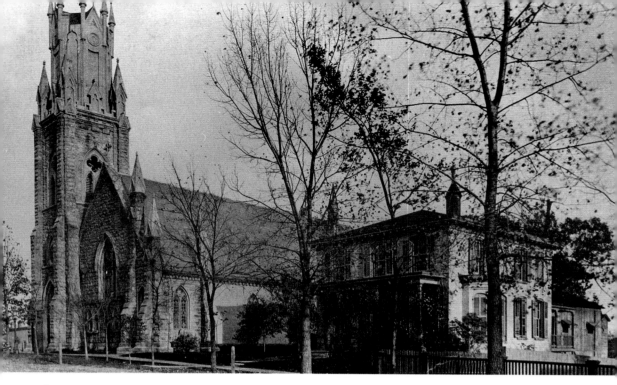

Grace Episcopal Church is one of the oldest churches in Cedar Rapids that is still in use on its original site. In 1851 a small brick chapel was constructed at A Avenue and Sixth Street NE and sections of this chapel survive. In 1873 the church was built closer to the avenue with a new limestone design that is still intact today.

Judge George Greene was a charter member of this church, and an impressive funeral ceremony was held in the church at the time of his death in June of 1880. Another section of the church was built in 1890.

The home on the right was used by the church as the residence of the pastor for many years and was a part of the Mansion Hill District.

In 1948, due to structural problems, a part of the church closest to Sixth Street (not visible in this photo) was demolished. In the 1960s when A Avenue was widened, the street was brought very close to the steps of this venerable church. (Top photo courtesy of The History Center, bottom photo courtesy of George T. Henry.)

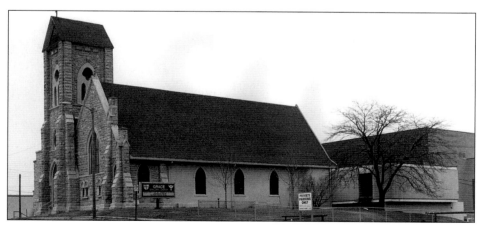

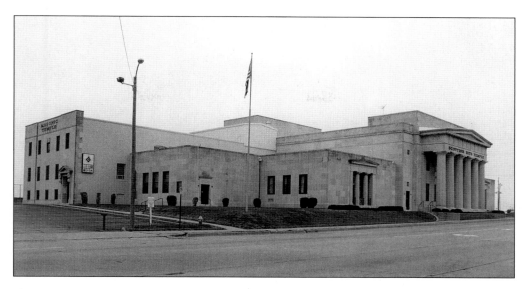

The Scottish Rite Temple building at 616 A Avenue NE was constructed in 1927 in classic Greek temple design at the highest point on Mansion Hill. The building incorporated the original 1910 Masonic Temple, which is on the left of the structure. In the 1970s, the Masonic Temple was redesigned to more closely match the 1927 Scottish Rite Temple.

Note that the building is closer to A Avenue now than when the first picture was taken. (Top photo courtesy of George T. Henry, bottom photo courtesy of The History Center.)

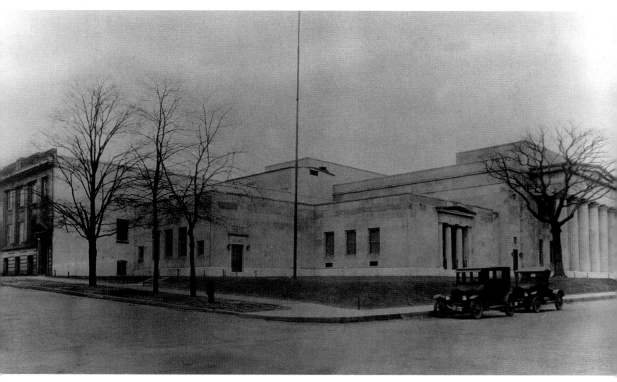

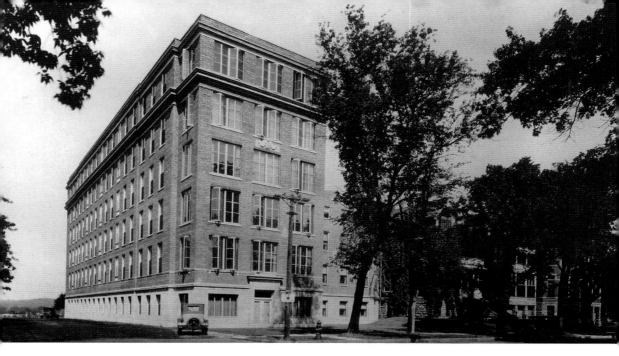

In the 1100 block of A Avenue NE stands St. Luke's Hospital. The main building was completed in 1884, built on ten lots donated by Judge Greene's widow and Sampson C. Bever. It was originally controlled by the Grace Episcopal Church and that control lasted until 1923, when a transfer was made to the Methodist Episcopal Church. It then became St. Luke's Methodist Hospital.

On the right, seen through the trees, is the original hospital. On the left is the addition, built in 1926. The original hospital buildings were removed in the 1940s, and the 1926 addition remains as the oldest part of the hospital. Many more additions have been made as the hospital enlarged. (Top photo courtesy of The History Center, bottom photo courtesy of George T. Henry.)

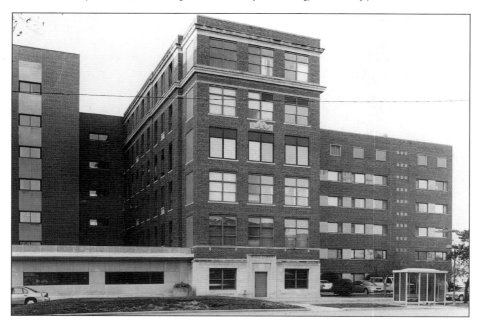

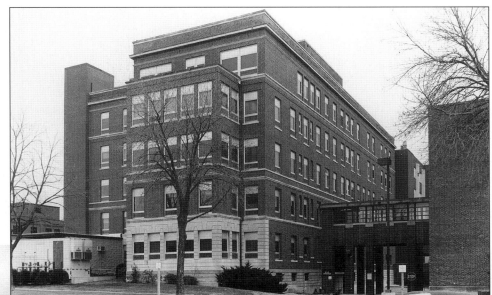

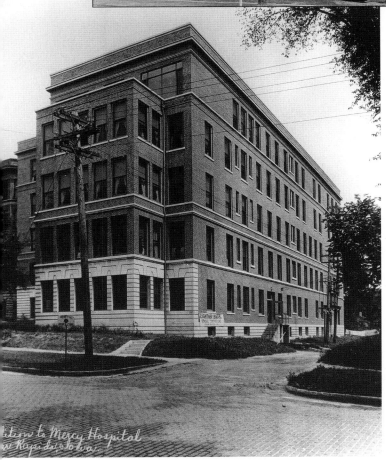

Mercy Medical Center began in a house at 603 Third Avenue SE in 1900. It was a 15-bed facility that very soon proved to be too small. The Sisters of Mercy acquired 12 lots in 1901 and in 1903 built their first building on Sixth Avenue between Eighth and Ninth Streets SE, a site that is now part of the current medical center. An addition to the 1903 structure was built in 1923, and numerous additions followed over the years. In 1971 the original 1903 structure was torn down, so this 1923 wing is the oldest surviving part of the hospital. The skywalk was added in 1946, and a large addition and new entrance on the Eighth Avenue side was made in 2002. (Top photo courtesy of George T. Henry, bottom photo courtesy of The History Center.)

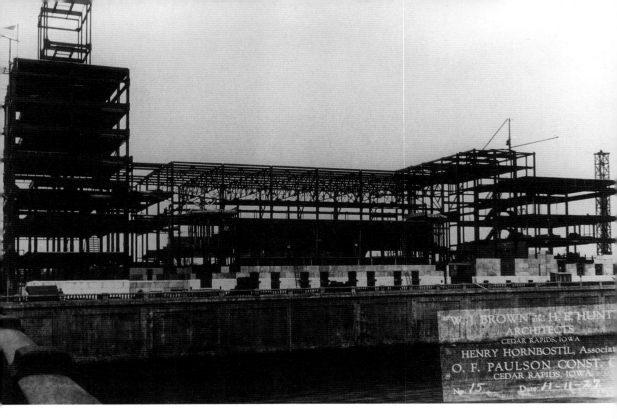

Prior to the construction of the Island Civic Center, May's Island only extended to Second Avenue from about Fourth Avenue. Fill dirt was brought in to nearly double the size of the island and provide a spot to build this landmark.

In this 1927 picture, the steel skeleton of the structure was visible during construction. The building was completed in 1928 and contains Cedar Rapids City Hall as well as Veterans' Memorial Coliseum.

In the earlier days, a natural gas eternal flame burned from the top of the building. Later it was deemed dangerous and the flame was extinguished. In 2000, a new permanent gold eternal flame sculpture was placed on top of the obelisk.

Note changes in the river walls as well as the bridge railing, looking west from the Second Avenue Bridge. (Top photo courtesy of The History Center, bottom photo courtesy of George T. Henry.)

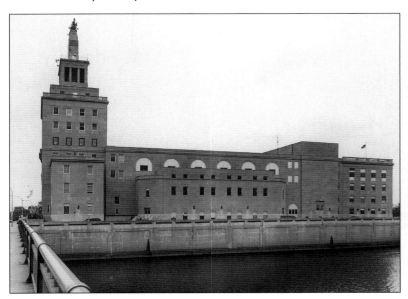

Chapter 6
MILLING AND HEAVY INDUSTRIES

Heavy manufacturing, milling, and meat packing were all prominent in Cedar Rapids in the early days. There were Quaker Oats, Cooper's Mill, Nicholas Brown's Mill, Anchor Mill, and several others. Most of them were at the river's edge and used the water power to do the grinding. Many of the early mills were started in the 1840s.

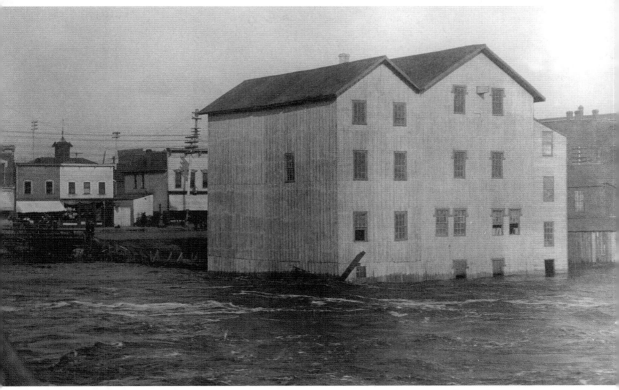

This photo shows Anchor Mill between First Avenue and the dam. The view is from the B Avenue Bridge (also called the F Avenue Bridge) as the river flooded in 1901. Anchor Mill stood until 1914 when a new dam, bridge, and millrace were built, followed by a hydroelectric plant in 1917. (Photo courtesy of The History Center.)

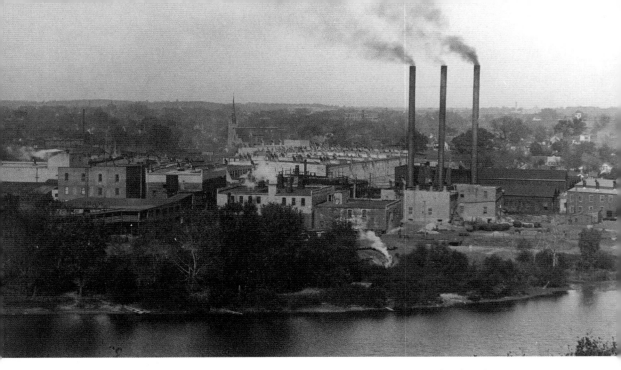

The T.M. Sinclair Packing House located at the end of Third Street SE, south of 14th Avenue, was started in 1871 by Thomas Sinclair, an Irish immigrant. He employed a large number of Bohemian (Czech and Slovak) immigrants for his labor force. The area surrounding the plant became a community center for the immigrants, resulting in what has become "Czech Village." Sinclair's plant was the fourth largest in the country in the 1880s. It was later known as Wilson Sinclair and finally as Wilson's. After time, Farmstead Foods took over the operation. The plant closed in 1990.

The photos were taken from across the Cedar River, looking east. (Top photo courtesy of The History Center, bottom photo courtesy of George T. Henry.)

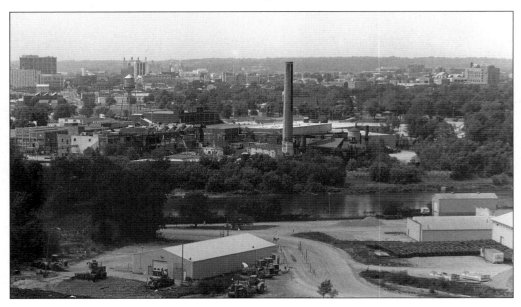

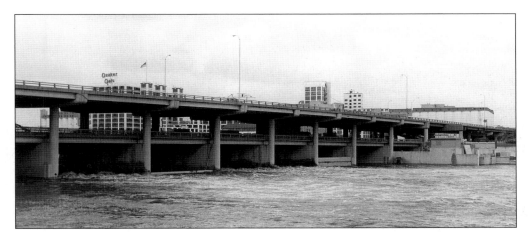

The roller dam on the Cedar River was probably built in the early days of Cedar Rapids, the mid-1800s, and provided a higher depth of water behind it. Also behind the roller dam is the early Quaker Oats plant. The 5-in-1 Bridge and dam was built not far from the original dam's location, and the Quaker Oats Plant is still visible behind it. The 5-in-1 Bridge and Dam was built in several sections, with the lower deck finished first in the late 1970s. Until both decks of the bridge were completed, however, Highway I-380 emptied into downtown Cedar Rapids, creating a great deal of traffic congestion. When the lower deck was finished, the F (or B) Avenue Bridge was demolished, and the bridge project was completed in 1978. (Top photo courtesy of George T. Henry, bottom photo courtesy of Sue Ohsman.)

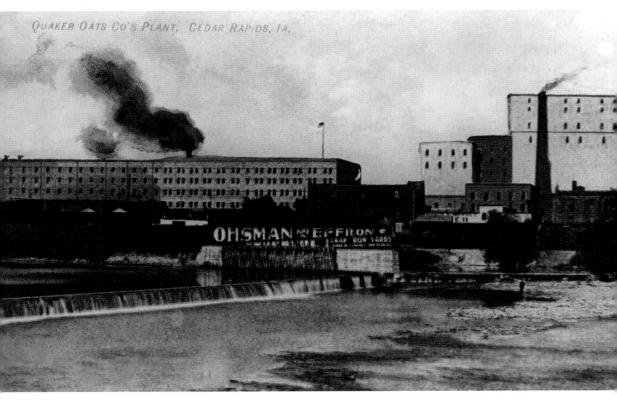

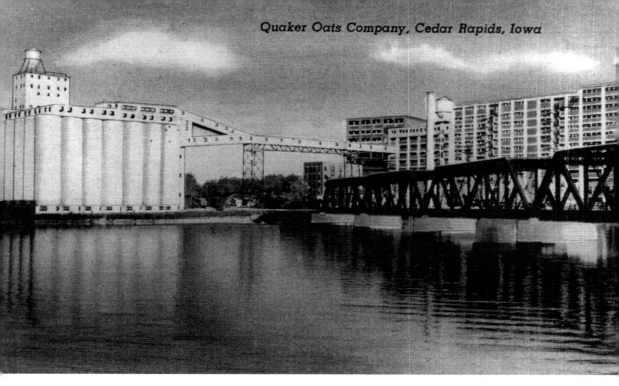

Virtually unchanged after 80 years is the massive Quaker Oats plant on the east side of the river. The Chicago and Northwestern Railroad Bridge, built in 1898, also remains little changed after 105 years. The railroad bridge crosses the Cedar River near the location of the old Hubbard Ice Company. The double-track bridge is still in continuous use. It was the second iron bridge to be built in this location; the first was constructed in 1860.

Quaker Oats, known for many years as the largest cereal mill in the world, was completely rebuilt after being destroyed in a 1905 fire. Many of the original structures are still in use 80 to 90 years after their construction. (Top photo courtesy of The History Center, bottom photo courtesy of George T. Henry.)

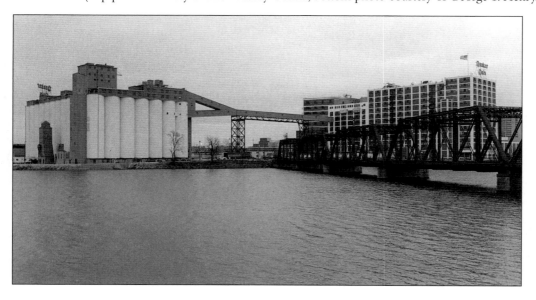

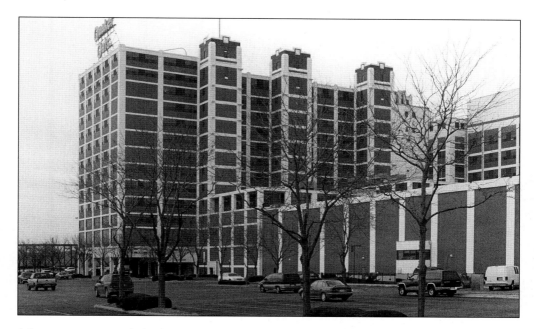

On Second Street NE, a great deal of change is evident. The old streetcar barns visible in this 1900 photo have been replaced by the Quaker Oats plant.

In the background of both pictures, however, is the old Chicago and Northwestern Railroad Bridge which is still in use today. In the middle of the picture is the old Cedar Rapids Waterworks plant, later replaced by a new city water processing facility on Shaver Road NE. (Top photo courtesy of George T. Henry, bottom photo courtesy of The History Center.)

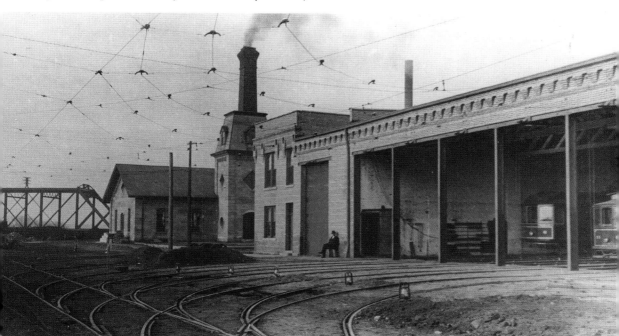

The power plant, at the end of Sixth Street NE, was built in 1887 and started production of electricity in January of 1888. The Cedar Rapids Electric Light and Power Company built near the slough, now known as Cedar Lake, because the water source was well-suited for the steam boilers used by the plant.

Many of the power plant's older structures are still functional today. The plant has expanded in recent years but is still in its original location. (Top photo courtesy of The History Center, bottom photo courtesy of George T. Henry.)

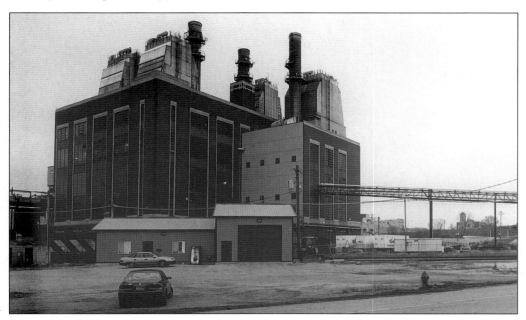

Chapter 7
PARKS

One of the reasons Cedar Rapids is considered a great place to live is the number of close-in parks. These were given to the city by forward-looking pioneers who still have their names attached to community landmarks, names such as Greene, Bever, Ellis, and Shaver. When the parks were acquired by the city, they were on the outskirts of town, but as the city grew and surrounded them, they became great parks within the city.

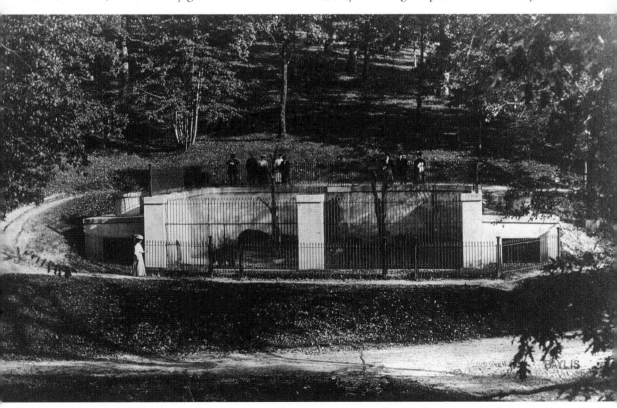

The bears in Bever Park have been gone a long time, but the bear pits constructed in 1904 remain. The bears were a big attraction in those early years. (Photo courtesy of The History Center.)

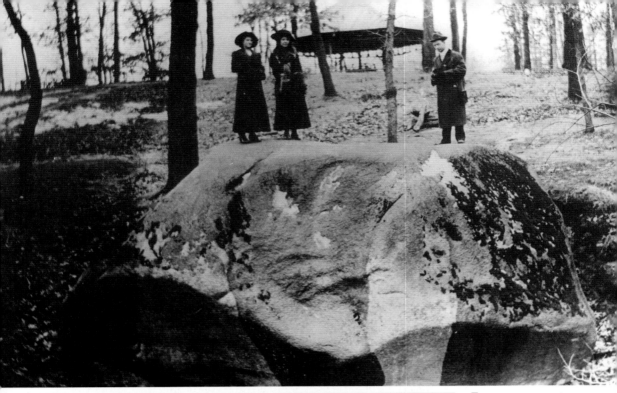

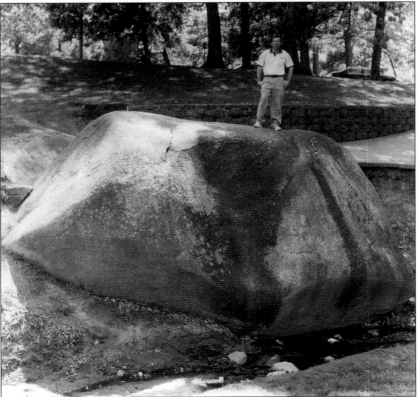

Everyone seems to know of the "rock" in Bever Park. It has been there since the glaciers leveled our land thousands of years ago and left this Ice Age residue. This picture of the rock was taken in 1914, and it still looks much the same. A close inspection, however, reveals that the right side of the rock has sunk just a little and is not quite as level as it was in 1914. We also see that in the last 90 years the rock has become much smoother, due to weather and use. (Top photo courtesy of Gene Pugh, bottom photo courtesy of George T. Henry.)

Originally Bever Park was the private property of the early Cedar Rapids resident Sampson Cicero Bever. Around 1900, the Bever estate gave the land to the city, and the park was established. One hundred years later much of the park is still untouched and remains a forest in the middle of the city.

In the early days of the automobile, the site was a destination for a Sunday drive. A few of the old stone bridges remain. (Top photo courtesy of George T. Henry, bottom photo courtesy of The History Center.)

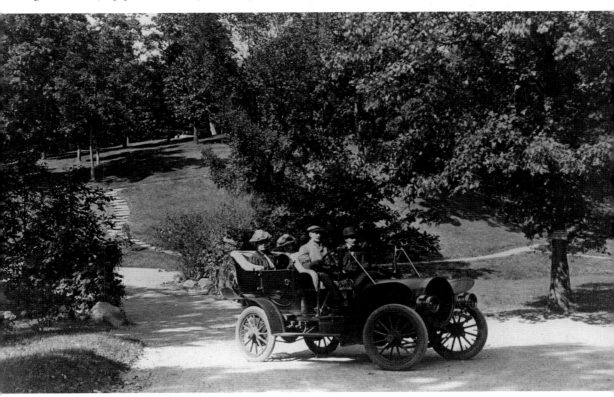

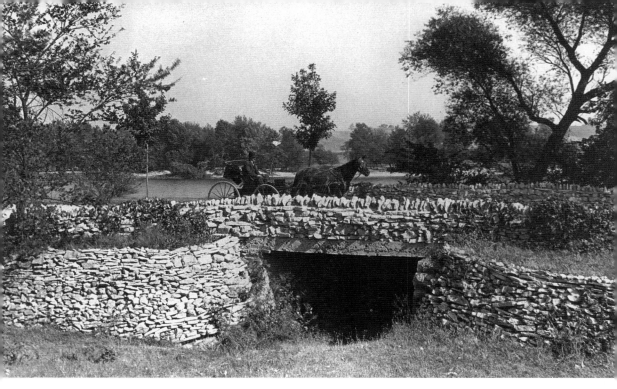

In the early days of the parks, roads were built to bring the residents "closer to nature." Bridges were built for these roads shortly after the turn of the century and many remain today. To have such a large and wonderful park system within Cedar Rapids is a tribute to the city's pioneers.

Robert Ellis was born in Pennsylvania in 1817 and arrived in Cedar Rapids on May 8, 1838, settling permanently on the west side of the river, northwest of the old community of Kingston. Ellis secured 160 acres and built his first frame house in 1856. In 1901, he made a generous donation by selling 47 acres of his land at half its value to the city of Cedar Rapids for use as a city park along the river. The park was immediately named in his honor, and 100 years later still bears his name. (Top photo courtesy of The History Center, bottom photo courtesy of George T. Henry.)

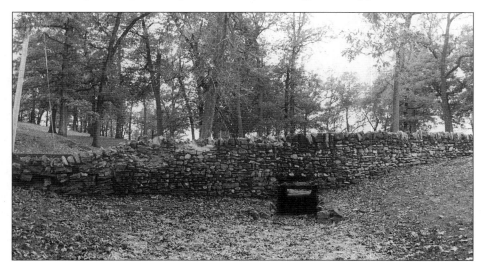

Riverside Park was established in 1894 on C Street SW and is Cedar Rapids' third oldest park. It had high swings and climbing bars, shown at the left of the picture, and was probably a very dangerous place to play. Many outings were held here because it was a public park with trees and grass and was within walking distance of downtown and close to the Bohemian neighborhood.

Today the park remains but has changed quite a bit. It still has swings but they are of much more moderate proportions. There is a softball diamond, and a skateboard park has been added recently. (Top photo courtesy of George T. Henry, bottom photo courtesy of The History Center.)

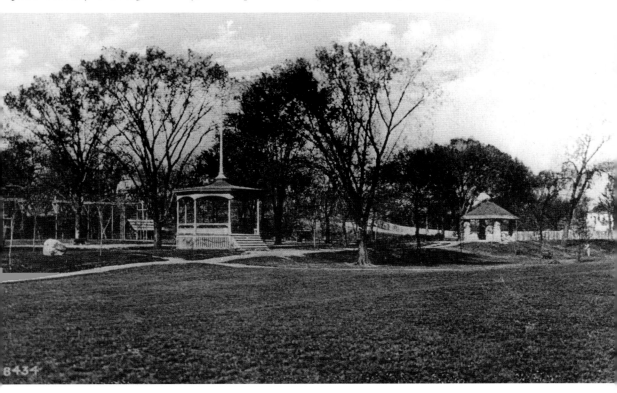

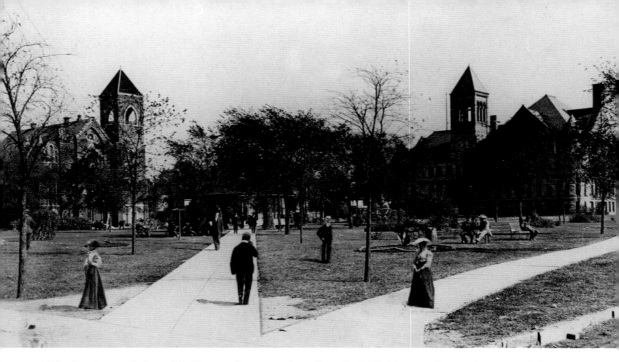

The book concludes with Greene Square, originally called Washington Square because of the proximity of the old Washington High School seen on the right. Greene Square was plotted as a park as early as 1843 and has always had a diagonal sidewalk going through it. Today, at the left of this sidewalk is a plaque honoring Judge George Greene, the very influential, generous, and civic-minded pioneer for whom the park is now named.

The park was across the tracks from Union Station, and as the trains arrived at the station the passengers were welcomed to Cedar Rapids by this beautiful park and the words "Cedar Rapids" inscribed with bold letters on the side of an earthen mound for all to see. (Top photo courtesy of The History Center, bottom photo courtesy of George T. Henry.)

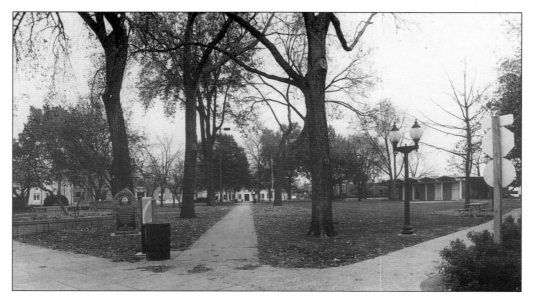